MW01051062

IMAGES
of America

DUTCH HERITAGE IN
KENT AND OTTAWA COUNTIES

IMAGES
of America

DUTCH HERITAGE IN
KENT AND OTTAWA COUNTIES

Norma Lewis and Jay de Vries

ARCADIA
PUBLISHING

Published by Arcadia Publishing
Charleston, South Carolina

Printed in the United States of America

Library of Congress Control Number: 2008943325

For all general information contact Arcadia Publishing at:
Telephone 843-853-2070
Fax 843-853-0044
E-mail sales@arcadiapublishing.com
For customer service and orders:
Toll-Free 1-888-313-2665

Visit us on the Internet at www.arcadiapublishing.com

*For our families, original, blended, and extended. We love you all.
In memory of Marcia Jacqueline Vanderwal de Vries.*

CONTENTS

ACKNOWLEDGMENTS

We could not have done this book without the help of the historians and history lovers at the various depositories of archival treasures. We thank the ever-helpful, ever-knowledgeable staff at the Grand Rapids Public Library, especially Christine Byron and Karolee Hazelwood, and also the Gary Byker Memorial Library in Hudsonville and the Patmos Library in Jamestown.

Thanks to Catherine Jong, archivist at the Holland Museum, Chris Penning and the Zeeland Historical Society, the Joint Archives of Holland, the Byron Center Historical Society, and the Tri-Cities Museum in Grand Haven. Heritage Hall at Calvin College's Hekman Library was a great source of information and inspiration. And a huge thank-you to Marilyn Hoek for navigating us through the treasures of the amazing Heritage Center at Graafschap Christian Reformed Church.

We appreciate the many companies, churches, and individuals that generously shared their storied pasts. You long ago recognized the importance of saving photographic documentation, and we are in your debt. We are in debt too, to our editor, Anna Wilson, John Pearson, and everyone at Arcadia for making the Images of America series possible.

INTRODUCTION

In 1846, when James Polk was president, the United States declared war on Mexico and annexed California and New Mexico. Carry Nation was born, Henry David Thoreau was jailed for tax evasion, and Antoine Joseph Sax patented his saxophone. In the Netherlands, Dominie (Reverend) Albertus C. Van Raalte prepared a group of 100 followers for a new life in a new land.

Government intervention in their worship practices motivated the Van Raalte party and other secessionist groups that followed. They deplored the state's liberal leanings and secretly conducted the traditional services they preferred in members' homes after being forbidden to do so in churches. When Van Raalte was arrested under the strictures of the Napoleonic Code, they deemed the situation intolerable. Economic hardships, including a potato famine, played a secondary role in the decision to seek a better life.

A few words come to mind when characterizing the Dutch. One is thrift. If they did not coin the dictum "Use it up, wear it out, make it do, or do without" they could have. Immigrants settling in America took jobs earning 75¢ a day and in two or three years had saved enough money to buy a house. Renting was viewed as wasteful.

Kitchens contained a *flessenkrabber*, a small spatula/scraper used to remove that last stubborn dab of jam or applesauce from the jar. Because the immigrants had lived through tough times in both countries, they worked hard and taught their children the value of a dollar. They acted from a belief that everything they had was a gift from God and not to be squandered. But their generosity was boundless when it came to building churches and schools and in contributions to charities and the community at large.

Hardworking also defines the Dutch. They "came the boat over" asking only for the opportunity to practice their faith without government intervention and a chance to earn a living. The uncut forests suggested fertile soil for farming. In the Netherlands they had built dikes and battled the sea, so they were up to the challenge of taming the southwest Michigan landscape. They felled trees for homes, planted crops, and raised livestock. They dug a channel from the Black River to Lake Michigan.

Some started businesses. Many companies have remained in the same family for generations. A Protestant work ethic provided a reliable workforce for the Dutch companies and also for the burgeoning furniture industry in Grand Rapids.

The Dutch epitomize cleanliness. Who else scrubs the streets before a parade? A scouring powder manufacturer took advantage of that perception and named its product Old Dutch Cleanser. In the old country, housewives gave their stoops a daily scrubbing.

They were devout Calvinists but also a bit fractious. While they shared core beliefs, they locked horns over the details, sometimes leaving a congregation to start their own. A joke tells of a Dutchman stranded for a year on a desert island. His rescuers asked him about the three crude structures he had built. "This is my house and that's my church," he explained. When asked about the third, he said, "That's the church I used to attend."

One

THE IMMIGRANTS

The early immigrants from the Netherlands required both courage and strength to endure a rigorous voyage that not all survived. Their arrival in New York was followed by an exhausting journey to southwest Michigan. Other secessionists followed soon after the Van Raalte party, putting down roots in nearby areas they named after the provinces from which they came: Vriesland, Graafschap, Overisel, Zeeland, Drenthe, and Bentheim.

Some of the early settlers were actually German. The countries shared an indistinct border and, because they were closely tied to the Dutch by geography, religion, and tradition, they considered themselves more Dutch than Deutsch. They conducted their Reformed church services in Dutch even before immigrating to Michigan.

Van Raalte chose an isolated wilderness at the mouth of the Black River to establish the *kolonie*. The February snow was sometimes waist deep, and the forest so dense it was impossible to properly swing an axe, but the tenacious Dutchmen forged on. They were not completely alone. Judge John R. Kellogg of Allegan accompanied the advance group of nine as they searched for a suitable location. George N. Smith, the missionary to the Ottawa Indians, made his home available to the settlers for preparing their food. They received support and encouragement also from Rev. William Ferry, who 12 years earlier had settled in what would become Grand Haven where he established the Grand Haven First Presbyterian Church.

As in all pioneer ventures, the settlers dealt with deprivation and diseases, including malaria, but there were high points as well. The first marriage took place on July 25, 1847, when Van Raalte officiated at the wedding of Jantjen Meijerink and Lambert Floris. The kolonie's first baby, Hermina, was born to Geesje Schutte Laarman and Jan Laarman in May 1847. Three years later the Laarmans had another daughter they named Hermina, so it would appear the first baby died.

As the area prospered, men sometimes returned to the Netherlands to find a bride, since American women did not meet their standards. W. H. de Lange, an immigrant teacher in Grand Rapids, labeled American women as "lazy, haughty, lacking in cleanliness and spendthrift. Even with a dowry of $50,000 they come too dear."

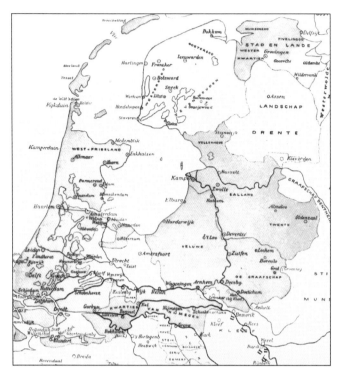

The map at right shows the Netherlands provinces from which the immigrants came, while the one below shows their settlements in Ottawa County, named for their former homelands. Closely following the Albertus C. Van Raalte party that settled in Holland in 1847 were settlers to Drenthe, Doornspijk, Graafschap, Groningen, Vriesland, and Zeeland. In 1848, Noord Holland (New Holland), Noordeloos, and Overisel were settled. Between 1860 and 1904, the Dutch established Borculo, Bentheim, Collerdoorn, Zoetermeer (Beaverdam), Haarlem, Harderwyk, and Niekerk. (Left, Heritage Center, Graafschap Christian Reformed Church.)

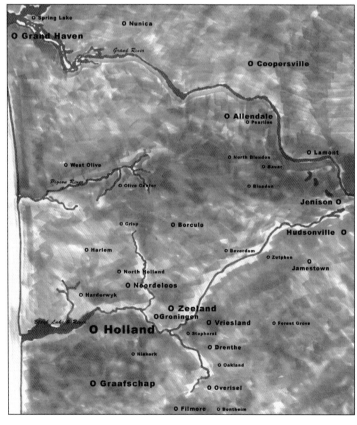

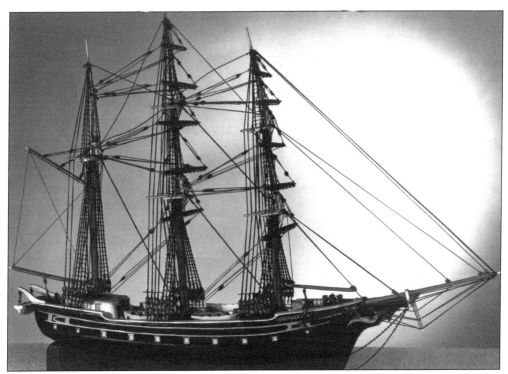

Shown above is a model of the sailing brig the *Southerner*, on which the Van Raalte party sailed from the port of Rotterdam on September 24, 1846, and endured a 55-day voyage to America during which three passengers died in steerage, including a child. (Holland Museum.)

Van Raalte continued to play a major role in the growing community. His first log church is now located in the Pioneer Cemetery. His new Ninth Street Church joined the Reformed Dutch Church of America in late 1849, after being invited to do so by Rev. Isaac Wyckoff of Albany, New York. Today that building is the Pillar Christian Reformed Church and still a Holland landmark. In 1856, he founded Holland Academy, the forerunner of Hope College and Western Seminary. (Holland Museum.)

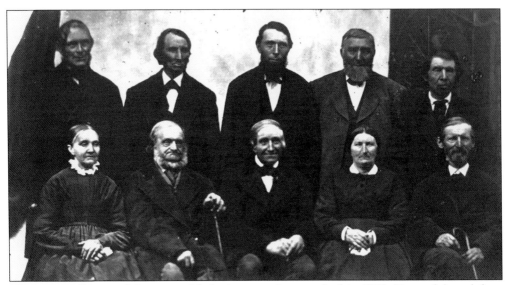

These men, all part of the original *kolonie*, were photographed in 1876. Pictured from left to right are (first row) Mrs. H. J. Laarman, Frans Smit, Manus Lankheet, Mrs. B. Grootenhuis, and Bernard Grootenhuis; (second row) Evert Zagers, Hendrik Jan Plaggemars, Teunis Keppel, Hein Vander Haar, and Egbert Frederiks. (Holland Museum.)

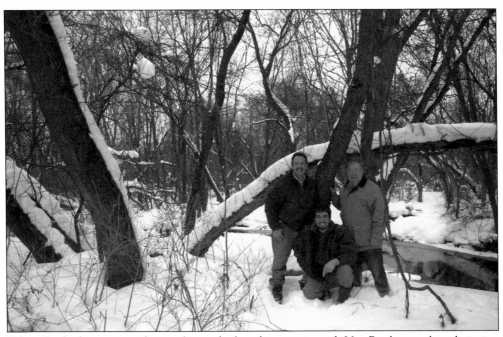

Egbert Frederiks was one of nine who made the advance trip with Van Raalte to select their site. Posing in the area where Van Raalte knelt in prayer are the fifth, sixth, and seventh generations of the Egbert Frederiks family. From left to right are Wayne Fredericks, his son Tim Fredericks, and his father, Bill Fredericks. Bill is the grandson of Egbert's grandson. At some point a *c* was added to the spelling. (Jay de Vries.)

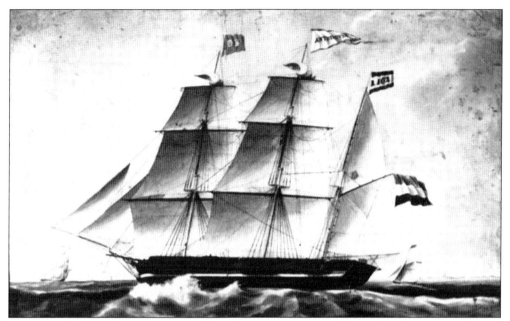

The *Antoinette* brought 70 immigrants from the Netherlands/Germany border towns of Drenthe and Bentheim to America. They sailed 49 days to New York and then traveled to Holland, Michigan. Van Raalte was too ill to offer assistance when they arrived in June 1847, but Jan Rabbers helped them buy government land for $1.25 an acre. (Heritage Center, Graafschap Christian Reformed Church.)

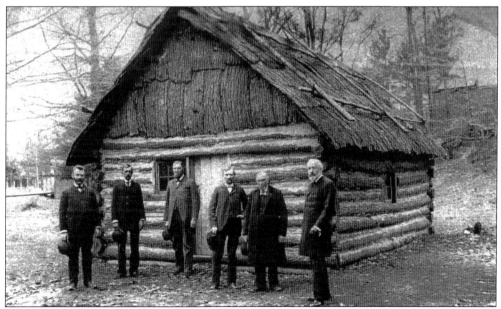

The log structure above is a replica of the first Dutch cabin in Holland and was built as part of the 1897 semicentennial, a celebration of 50 successful years in the immigrants' adopted country. The settlers posing in front are, from left to right, G. J. Diekema, J. T. Kanters, A. Vissher, G. Van Schelven, I. Cappon, and G. J. Kollen. (Holland Museum.)

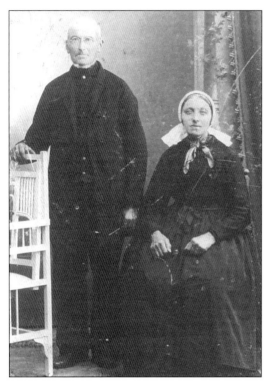

Hendrik Geukes and his wife, Arendina (Te Van Holt), planned to leave Borculo, in the Netherlands, for a new life in America. Some family members had already made the move, Though Arendina died, Hendrik followed through. Below, he poses on the family farm in Jamestown with four of his sons. (Ron Strauss.)

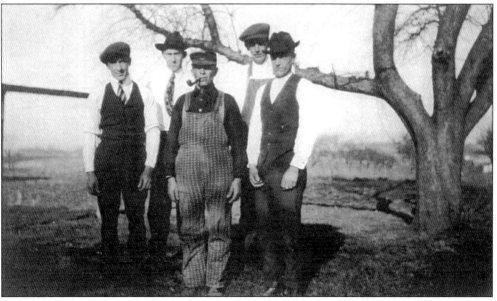

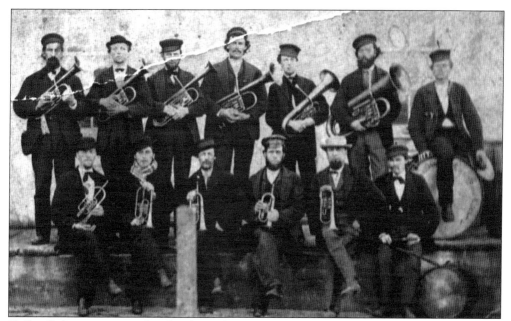

Holland's first community band is shown here in full dress. From left to right are (first row) Jake Vander Rovaart, Cornelius Vershure, John Grootenhuis, W. J. Scott (leader), "Yankee Dan" Marvell (teacher), and Jack Demick; (second row) Grant Scott, John Roost, Dr. Bill Van Putten, Lee Collens, Gus Labarge, John Kramer, and Al Finch. (Holland Museum.)

In the earliest days, each settlement stayed true to the area of the Netherlands from which the people came. Here the New Zupthen Singers bring a touch the old country into the new. John Vander Heida is on the far left, Herman Telgenhof, far right. (Gary Byker Memorial Library.)

15

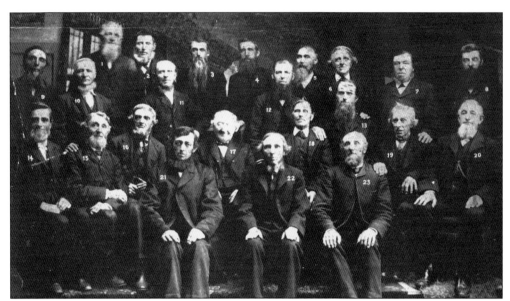

A group led by Rev. Cornelius Van Der Meulen, Jannes Van De Luyster, and Jan Steeketee settled Zeeland in 1847, soon after the Albertus C. Van Raalte kolonie. Photographer Isaac Ver Lee took this photograph of the Zeeland pioneers in 1887. Pictured are Bernend J. Veneklaasen (1), Frank Hornstra (2), Hon. Cornelius Van Loo (3), Albert Riddering (4), John W. Goozen (5), Jan Den Herder (6), Jan Van Eenenaam (7), John P. De Pree (8), Joseph Westrate (9), Peter Huyser (10), Jan Huizenza (11), Govert Keppel (12), Hon. Jacob Den Herder (13), Rev. John's Van Der Meulen (14), Albert Huizenga (15), Hubregt Van Noorden (16), Huibert Keppel (17), Melle Van Den Bosch (18), Jacob De Feyter (19), Hendrik De Kruif (20), Otto Yntema (21), Hendrik Pyl (22), and Albert Lanning (23). (Zeeland Historical Society.)

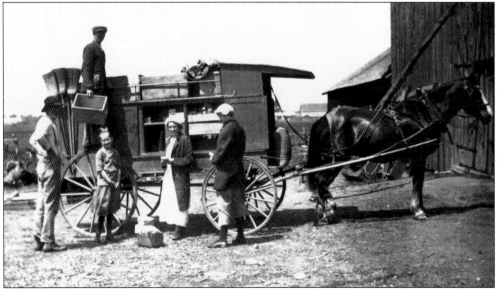

Doctors were not the only ones who made house calls in the early days. Peddlers making periodic rounds with wagons stocked with grocery and small household items were a great convenience in chore-filled days that began before dawn and continued long into the evening. (Zeeland Historical Society.)

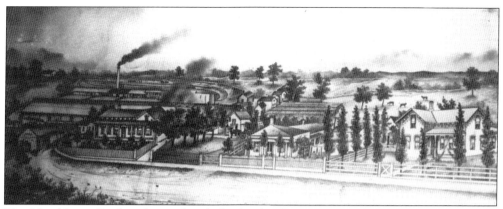

The Veneklasen Brickworks produced the bricks that represented a popular 19th-century architectural movement in Michigan. The company turned out 400,000 bricks in 1860; 800,000 in 1865; and 1.5 million in 1872, after installing laborsaving machinery. This drawing may have been done by a hobo in 1883, in exchange for food. (Calvin College, Heritage Hall.)

Loamy soil near Zeeland and Hudsonville yielded clay for brick making, most notably by the Veneklasen Brickworks. (Calvin College, Heritage Hall.)

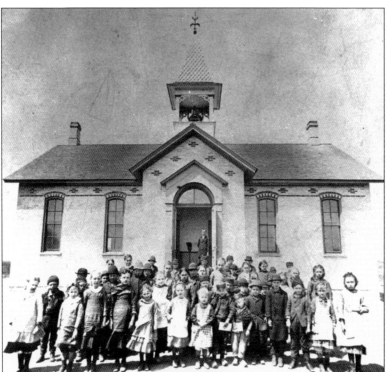

Students pose in front of the New Groningen school in the mid-1880s. Two of the boys in the front row are wearing wooden shoes. Note the decorative Veneklasen brick on the building. (Calvin College, Heritage Hall.)

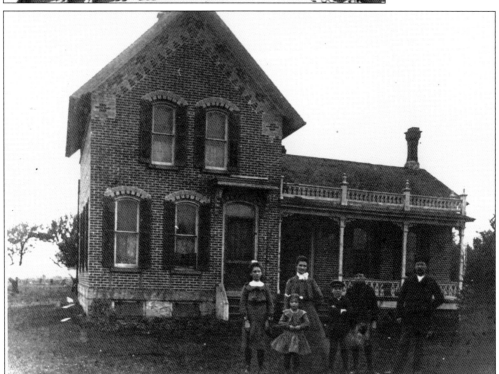

The Schaap family of Holland is in front of its Veneklasen brick house in the 1880s. (Calvin College, Heritage Hall.)

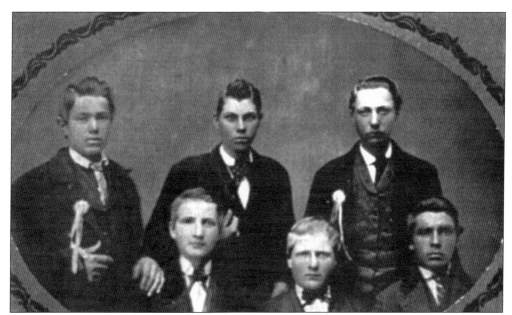

These six single Graafschap men volunteered for the Civil War in March 1865 so that six family men who had been drafted would not have to serve. From left to right are (first row) Cornelius Lokker, J. H. Eppink, and Mattheus Notier; (second row) Germ W. Mokma, Gerrit J. Nyland, and John (Jan) Douma. Notier and Douma had the honor of guarding the funeral bier of slain president Abraham Lincoln. (Heritage Center, Graafschap Christian Reformed Church.)

In 1862, at age 18, Dirk Van Raalte (shown here in later years), son of Albertus C. and Christina Van Raalte, enlisted in the 25th Michigan Infantry and fought in the Civil War. He returned home after being wounded in Atlanta and 12 years later began his term as a state representative. Dirk's older brother Benjamin had enlisted a week earlier on August 14. (Calvin College, Heritage Hall.)

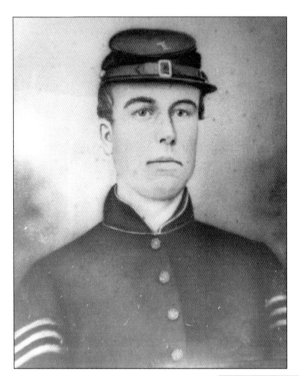

Benjamin Van Raalte took part in General Sherman's march through Georgia and was promoted to sergeant after rescuing his unit's colors under enemy fire. The flag he saved is now displayed in Michigan's state museum in Lansing. (Joint Archives of Holland.)

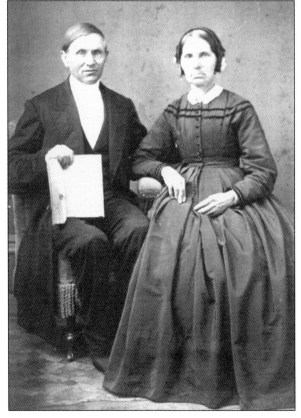

Dominie and Mrs. Koene Van Den Bosch posed for this formal portrait in 1866. Six years earlier, Vanden Bosch's Noordeloos congregation along with clergy and members of three other area Reformed Church of America churches voted to withdraw from the denomination in favor of an independent status. (Calvin College, Heritage Hall.)

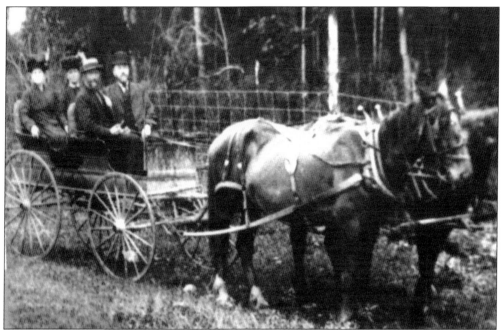

The church was, and for many still is, the core of the Dutch experience. After housing and barns, the first structure in any new settlement was a church. Many still attend both morning and evening worship services each Sunday. While the two couples in the buggy above appear to be enjoying the ride, that was not always the case. Inclement weather was no excuse for staying home on Sunday mornings in the 1890s so the hardy folks shown below dressed warm and trekked to church in Graafschap. Note the barns for those who drove their horses. (Above, Heritage Center, Graafschap Christian Reformed Church; below, Calvin College, Heritage Hall.)

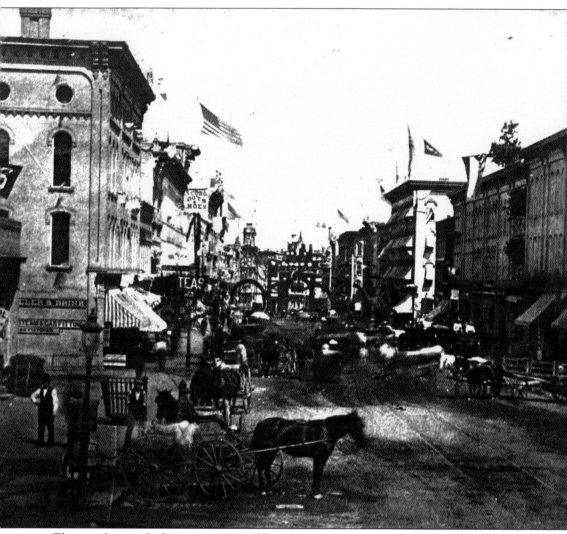

This was the view looking west in Grand Rapids on Monroe Avenue during the 1876 centennial. Among the city's many Dutch mercantile establishments was Brummeler and Brinks Grocery, located at 117 Monroe Avenue and shown on the left. (Grand Rapids Public Library.)

Before the dawn of the 20th century, Zeeland's Main Street could meet all the residents' shopping needs and even offered the convenience of wooden sidewalks. (Calvin College, Heritage Hall.)

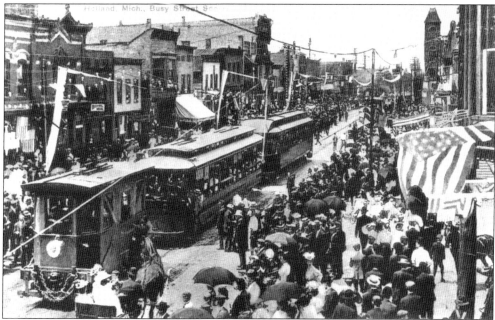

At the end of the 19th century, Holland residents crowd the streets where they have the luxury of riding trolleys for ease in transportation. (Calvin College, Heritage Hall.)

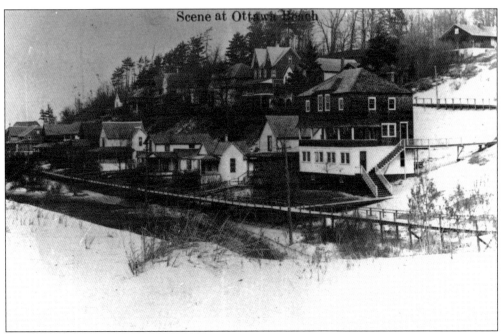

By 1900, Ottawa's Lake Michigan and Lake Macatawa shores were being developed into a resort area. Visitors from Chicago and other parts of Michigan could enjoy the sugar sand beaches and bring needed tourist dollars into the community. (Calvin College, Heritage Hall.)

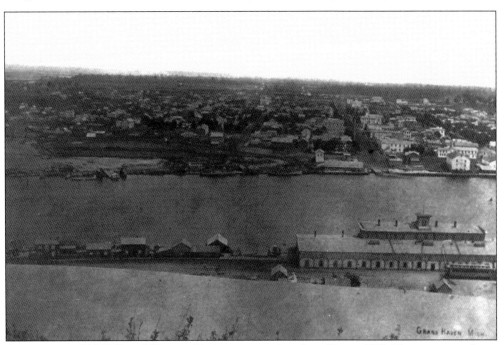

An overview of 1869 Grand Haven, this image was taken from Dewey Hill. The passenger depot of the Detroit and Milwaukee Railroad is in the foreground, on the channel between the Grand River and Lake Michigan. In 1878, the railroad reorganized under the name Detroit, Grand Haven and Milwaukee Railway Company. (Calvin College, Heritage Hall.)

Two

AGRICULTURE

After clearing the land, the settlers found the region ideally suited for agriculture. Farms were a family business, and the farmer's "board of directors" to which he felt accountable consisted of God, his family, and his community. As long as he had done his best, he held his head high, knowing that droughts, floods, hail, and destructive winds were acts of God and beyond his control.

He avoided debt whenever possible, but when it proved inevitable he approached his bank with confidence. The bank was not a corporation either, and the banker worshiped with the farmer. Their children played ball together and studied the Heidelberg Catechism together. He knew the loan was safe. Their handshake sealed the contract.

Early farmers did not attend agricultural college. They knew every inch of their land, so farm economics meant learning by trial and error what worked best and building on the strengths. Dairy farmers prospered. Entrepreneurs established creameries and cheese-processing plants. One creamery became the locally loved Hudsonville Ice Cream. Another evolved into the Koeze peanut butter, nuts, and candy company.

Zeeland reigned as the poultry capital of the region. Bill De Witt raised turkeys in nearby Borculo and became known as the "Turkey King" with his Bil-Mar company. The "Mar" was for his brother and partner Marvin. Their company is now part of the Sara Lee empire. Chickens played such an important role in the region's farm economy that the local semiprofessional baseball team was called the Chix, also the name of today's East Zeeland High School athletic teams.

The Drenthe Canning Company and a Heinz pickling plant in Zeeland provided a steady produce market, as did the farmers' markets in Grand Rapids. Both counties are in the southwestern Michigan fruit belt, famous for its blueberries and orchards.

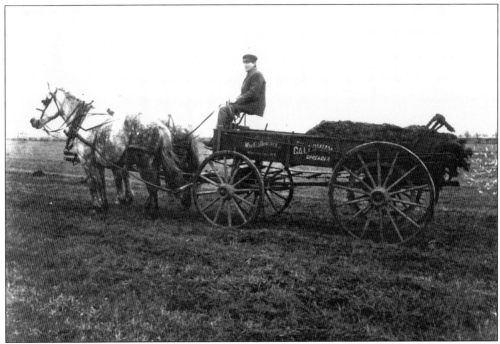

Spreading manure was just one more chore for Egbert Boone, perched on the edge of his wagon to put as much distance as possible between himself and his fragrant cargo. He farmed in New Groningen, and this photograph was taken in the 1880s. (Calvin College, Heritage Hall.)

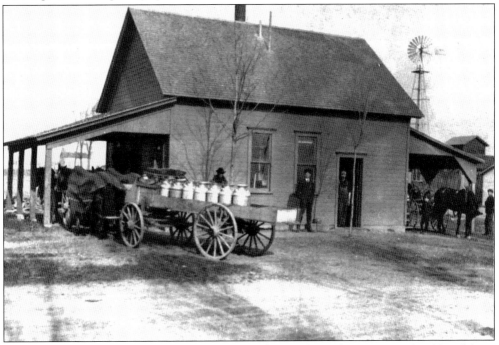

Dairy farming in the area increased to the point where a cheese factory opened in Noordeloos, making it possible for farmers to sell their milk without traveling to Grand Rapids. (Calvin College, Heritage Hall.)

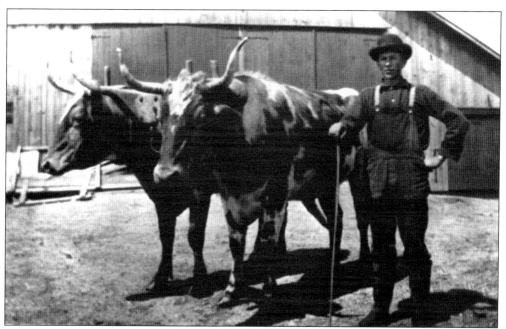

Some of the immigrants came to Michigan by oxcart. Farming was grueling and often dangerous work, with no shortcuts for man or beast. A pair of oxen made clearing land and other difficult jobs a bit less labor intensive. (Calvin College, Heritage Hall.)

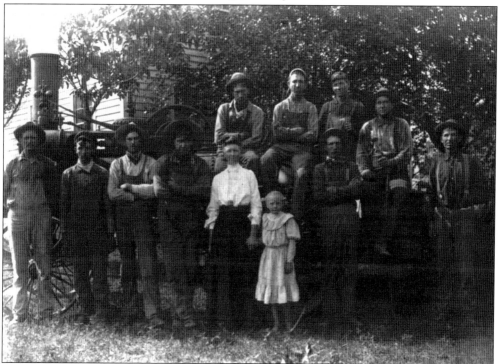

Even with a large family of boys, a steam tractor represented a welcome laborsaving device at the dawn of the 19th century. Here the Driesengas pose on their farm near Holland sometime before 1910. (Calvin College, Heritage Hall.)

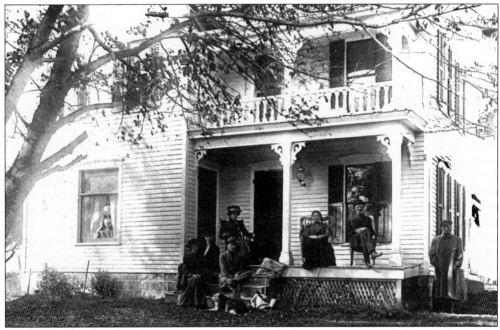

The Ensink family of Hudsonville poses outside its farmhouse in the 1880s. From left to right are (first row) Truda Ensink Heyboer, Bert Ensink, and Fred Ensink; (second row) Jennie Ensink Ringerwole, Gezina Ensink, Albert Ensink, and Nick Ensink (standing). Their home was built in 1879 on the northwest corner of Thirty-second Street and Quincy Avenue. The Ensinks bought the 160-acre homestead in 1882. Bert Ensink bought the 60 acres on the north side when he married Edith Kroodsma. (Gary Byker Memorial Library.)

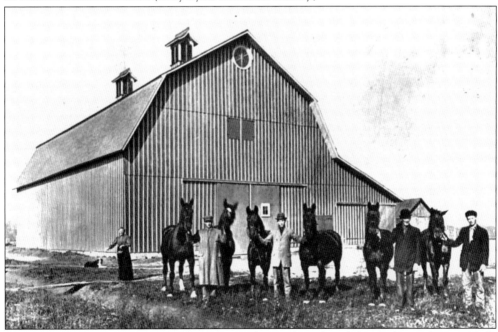

The Ensinks' barn looked like this in 1904. Standing in front from left to right are Gezina, Nick, Fred, and Bert Ensink along with some hardworking horses. (Gary Byker Memorial Library.)

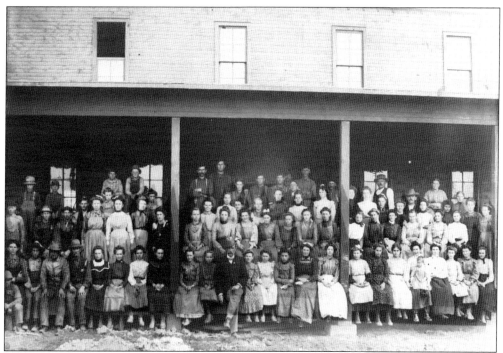

Fertile farmland meant sufficient produce to satisfy local needs and support commercial canneries as well. The Drenthe Canning Company provided jobs and made good use of the abundant pickling cucumber crops. Employees photographed here in 1900 in their long sleeves and aprons must have sweltered inside the factory prior to air-conditioning. (Zeeland Historical Society.)

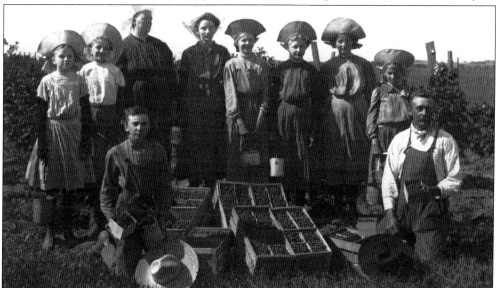

Summertime in Ottawa County has always meant berries: fat, sweet, juicy blueberries, strawberries, and raspberries. Farmers like the Zelders hired pickers and also opened their fields to buyers to pick their own. These pickers are, from left to right, (first row) Garret Buter and Mr. Gelder; (second row) Minnie Butler, Bertha Poest, Mrs. Gelder, Jo Danhof, Margaret Poest, Delia Poest, Jennie Ozinga, and Gertude Geerts. (Zeeland Historical Society.)

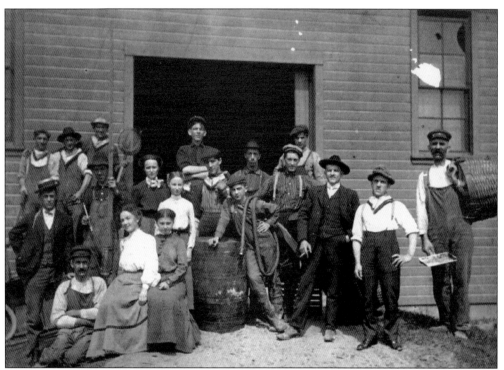

The H. J. Heinz Company operated a pickle station in nearby Borculo, meaning that farmers had yet another outlet for their crops and more jobs were available without leaving the local community. (Zeeland Historical Society.)

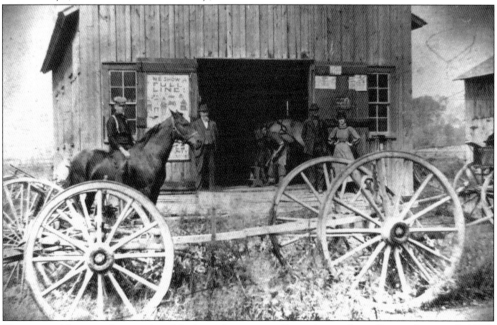

Times would soon change, but blacksmiths were still in demand in Overisel around 1900. Horseless carriages were now a possibility, but most people still needed men like Henry Lampen to shoe their horses, not patch their tires. (Calvin College, Heritage Hall.)

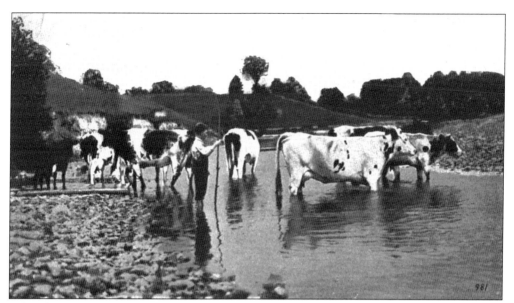

A boy herds his prized black-and-white cattle across a stream near Zeeland. An 1873 immigrant complained that out of 100 Michigan cows, 99 were red, unlike the black and white beauties back home in Friesland. (Calvin College, Heritage Hall.)

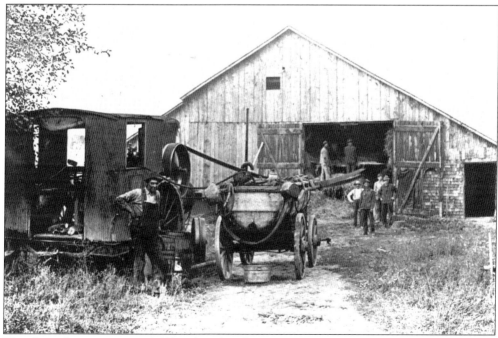

Threshing the grain required all hands. Often farmers formed teams and went from farm to farm to do the job more efficiently. Providing a rib-sticking lunch for the hardworking farmers became a friendly competition among the ladies. (Calvin College, Heritage Hall.)

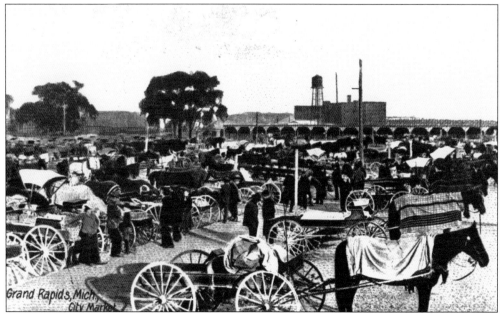

As early as the 1890s, truck farmers converged on the Leonard Street City Market in Grand Rapids to sell their crops to city folks not lucky enough to pick their corn while the water boiled or smell their tomatoes ripening on the vine. (Calvin College, Heritage Hall.)

Poultry was a major farm industry in the 1920s around Zeeland. Determining whether the peeps were pullets or cockerels required specialized knowledge. Dwight Wyngarden attended a chick sexing school and could process 1,000 chicks an hour. Wyngarden is believed to be the gentlemen in the middle wearing a coat. The other men (not in order) are Ivan Hartgerink, Ernest Ossewaarde, Preston Borr, Pete Zeedyk, Henry Klamer, Bud Wierenga, and E. Wesley Faber. The women are Gertrude Van Hoven and Maybelle Froelich. (Zeeland Historical Society.)

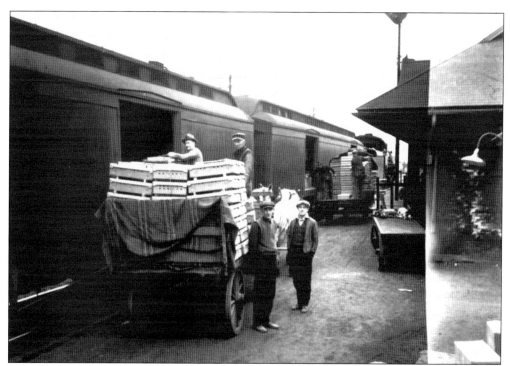

These live peeps are boxed and ready for rail shipment via the Pere Marquette Railroad in 1928. Not all baby chicks traveled by train, however; some were mailed. (Zeeland Historical Society.)

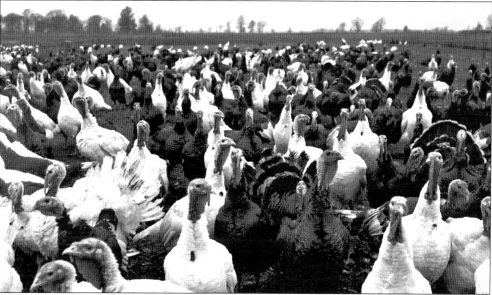

If Bill De Witt of Bil-Mar turkeys in Borculo was in fact the Turkey King, these must be a few of his loyal subjects. In 1978, De Witt presented the late president Gerald R. Ford with a bird for the official presidential Thanksgiving turkey-pardoning ceremony. Before Ford became president, he had served as representative from Michigan's Fifth Congressional District. During his speech, he singled out De Witt and inquired as to the state of affairs in Borculo. (Grand Rapids Public Library.)

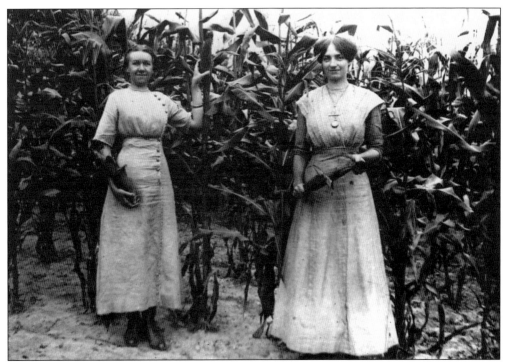

Their corn may not yet be "as high as an elephant's eye," but these ladies are proud nonetheless. Although celery was Hudsonville's claim to fame, other crops, including corn, cucumbers, cabbages, onions, carrots, squashes, and cauliflower, flourished as well. (Calvin College, Heritage Hall.)

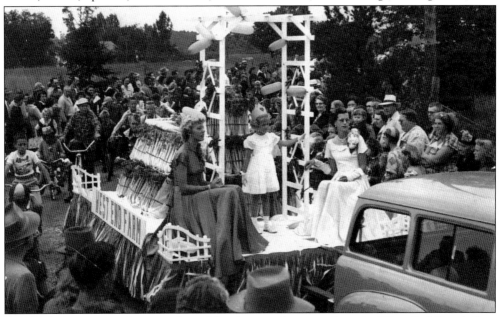

Everybody loves a parade, as evidenced by the crowd surrounding the West End Farm's float in the Fourth of July celebration. It showcases Hudsonville's signature crop—celery. The floats have become more sophisticated over the years, but one thing has not changed: Ottawa county's muck farms still yield an abundance of celery. (Gary Byker Memorial Library.)

Hatcheries were big business in and around Zeeland. The farmers' wives were equally committed to making them successful. Toward that end, they formed an auxiliary. The number of women shown above indicate the scope of the poultry industry in the area. (Zeeland Historical Society.)

The Moelker family, Netherlands immigrants, began farming in 1907 in Talmadge Township. Today's Moelker's Orchards remains in the original family and, with its apples, peaches, berries, and rhubarb, is one of many farms in the two counties keeping southwest Michigan's reputation for superior fruit intact. Cousins are, from left to right, Maryjo Moelker, Chuck Vugteveen, Ron Moelker, Russ Moelker, and Doug Vugteveen in 1956. (Moelker family.)

Jacob Nagelkirk of Grand Rapids is on a quest for a perfect jack-o-lantern. These squashes came from the pumpkin patch at the Brookside Gardens truck farm. (Grand Rapids Public Library.)

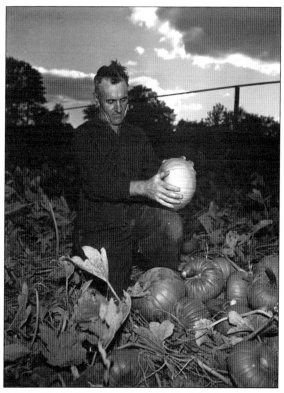

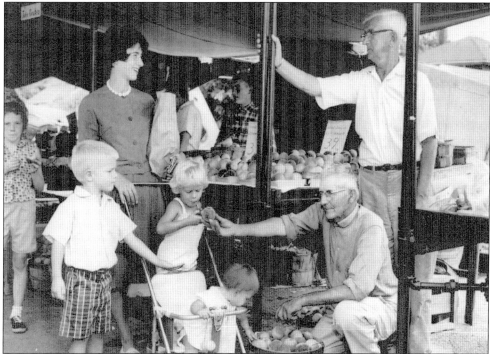

Gerrit Geukes sold his peaches at the Grand Rapids Fulton Street Farmer's Market in 1958. The girl in front is sure to have enjoyed her juicy sample. (Ron Strauss.)

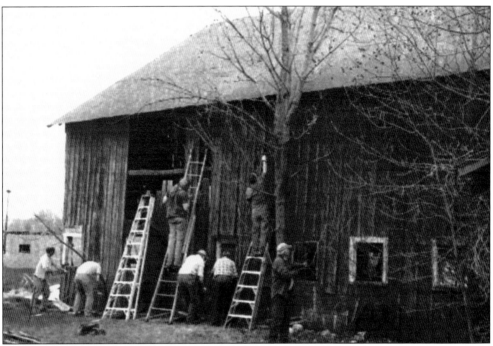

This old barn once stood in front of Allendale High School and is now part of the Coopersville Farm Museum. Volunteers are removing the siding in preparation for the move to Coopersville. (Photograph by Lee Ann Creager, director; Coopersville Farm Museum.)

The Coopersville Farm Museum honors the history of farming and the memory of Peter Hannenburg. The driving force behind the museum, Ed Hannenburg, operator of the River Ridge Farms, planned a 12,000-square-foot facility with rotating exhibits, interactive events, and a showcase for his vintage John Deere collection. (Photograph by Lee Ann Creager, director; Coopersville Farm Museum.)

Three

COMMERCE
AND INDUSTRY

The Dutch brought from the old country a strong Protestant work ethic that served them well. Some had an equally strong independent streak that led them to start their own businesses. It might be said that they were just too stubborn to work for anyone else.

Others fell into business by default, like Edsko Hekman. Shortly after his arrival he applied for a school custodian job. He was not hired because he did not speak English well enough. In the Netherlands he had been a baker, so not knowing what else to do, he baked cookies that his children sold door-to-door. Eventually he opened a bakery that became the Hekman Biscuit Company, a commercial cookie factory. Eventually that factory was bought by Keebler and then Kelloggs. Jay de Vries recalls Hekman speaking about using what one has to overcome adversity. "If I'd spoken better English," he said, "I'd still be a janitor."

Edsko Hekman's three sons founded the Hekman Furniture Company. Other Dutch Americans became pharmacists, wholesalers, retailers, and builders. Some started greenhouses and nurseries. They opened small businesses that supported the furniture industry and other manufacturers. When the furniture industry went south, they tapped into the growing automotive market, turning out parts and after-market products.

Companies with Dutch origins still play a major role in the southwest Michigan economy. Christian publishing giants Eerdmans, Baker, Zondervan, and Kregel are all headquartered in the Grand Rapids area. So, too, are Meijer Inc., Gordon Food Service, Amway, and Koeze. Based in Ottawa are Russ', Big Dutchman, Holland Rusk, and Hudsonville Ice Cream. The Prince Company is now part of Johnson Controls.

Car dealerships were overwhelmingly Dutch owned and included Gezon, Van Andel and Flikkema, Betten, Alberda Shook, Kool, Duthler, Van Houten, Pheiffer, Ver Hage, Borgman, and Lemmen. Most are still in business and still in the same family.

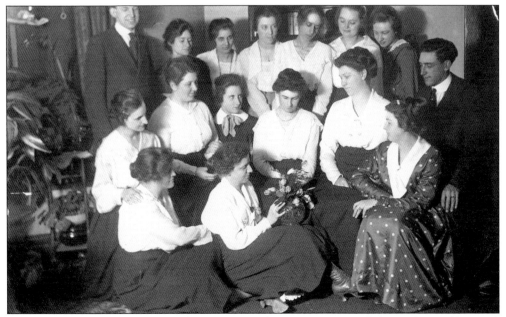

Citizen's Telephone Company employees are seen here in 1919. From left to right are (first row) Anna Cook and Nettie Brill; (second row) Gertrude Elenbaas, Dora Veneklasen, Gertrude Boone, Minnie De Bruyn, Marie Van Dyke, Frances Van Dyke, and repairman James Ver Lee; (third row) repairman Ralph Brill, Feuna Van Vessem, Minnie Van Loo, Agnes Wyngarden, Ella Vander Velde, Nell Karsten, and Jeanette Vander Werf.

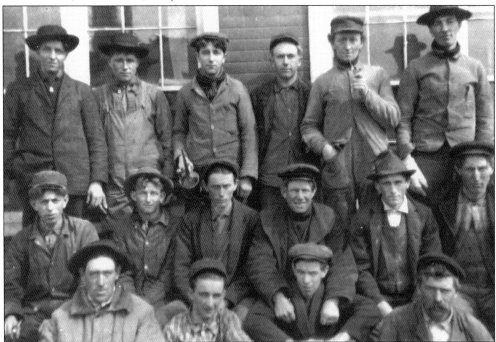

The immigrants brought with them a strong Protestant work ethic, making them valued employees in the local industries. These Zeeland workers pose outside the G. Moeke and Son sawmill and box factory in 1906. (Calvin College, Heritage Hall.)

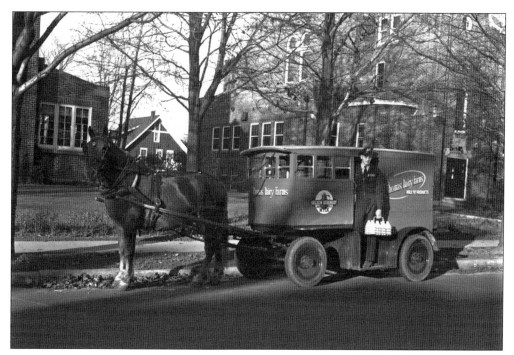

Thomas Dairy Farms milkman Fred Ondersma and his horse Charlie were fixtures in Grand Rapids. Charlie knew which customers received milk only on Saturdays and trotted past those houses on weekdays. He was known for helping himself to a drink of garden-hose water at any house where someone was watering the lawn or washing the car. (Grand Rapids Public Library.)

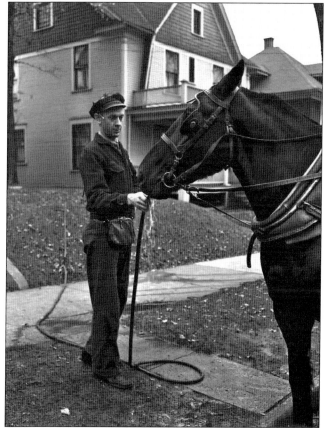

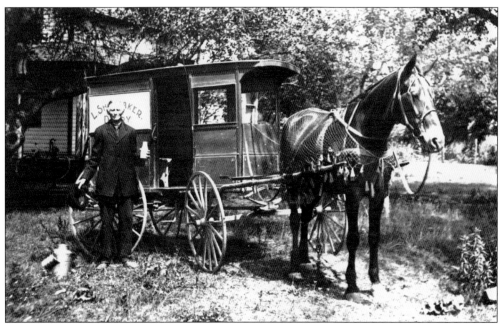

Lawrence Shumaker, shown holding a milk bottle with a can on the ground beside him, operated Shumaker Dairy and sold his product door-to-door in Zeeland. Note the fancy blanket on the horse's back. (Zeeland Historical Society.)

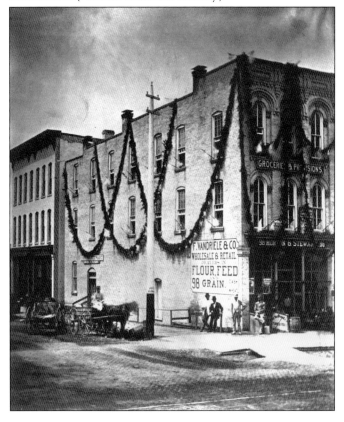

Vandriele and Company, wholesale and retail purveyors of feed, flour, and grain, hung festive garlands when the founder's adopted country celebrated 100 years of independence from England in 1876. (Calvin College, Heritage Hall.)

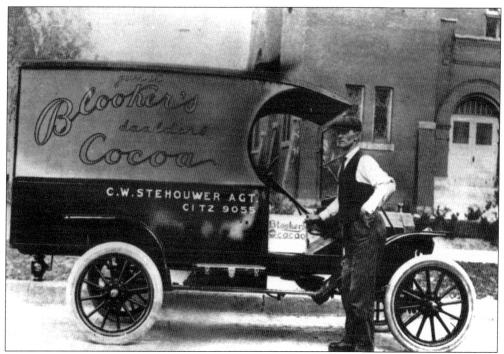

C. W. Stehouwer delivered his cocoa products in a horseless carriage in the early 1900s. Imported Netherlands chocolate was considered a tasty Dutch treat—and still is. (Calvin College, Heritage Hall.)

The Verbrugge family stands in front of Faber's Dry Goods Store, Verbrugge Barber Shop, and Plafken Shoe Repair on East Fulton Street, a Dutch enclave in the 1880s. (Calvin College, Heritage Hall.)

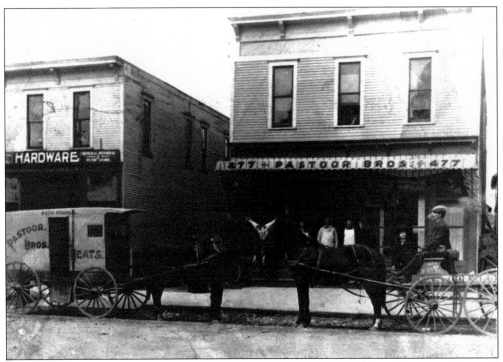

The Pastoor brothers, Bene, John W., Cornelius, and Albert, operated several meat markets and stores in the early 20th century. This one is at 477 South Eastern Avenue, another neighborhood to which the Dutch funneled. Grand Rapids city directories show they also had shops on Division Avenue and by the 1930s had located on Michigan Street Hill. (Calvin College, Heritage Hall.)

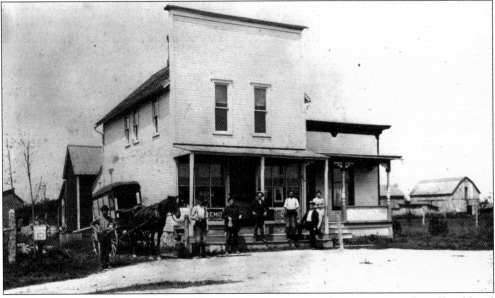

Not only did every city neighborhood have its own grocer, rural communities also offered local shopping for groceries and essentials. The Grandville General Store shown above is typical. (Calvin College, Heritage Hall.)

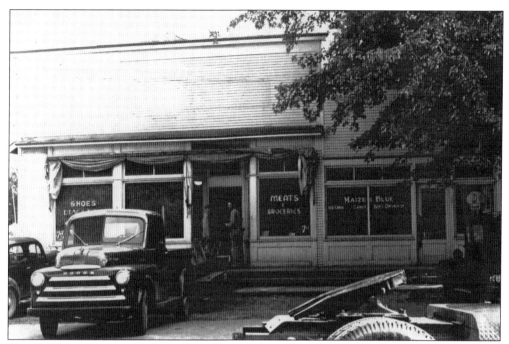

The DeWeerd Store in Hudsonville sold everything from shoes and dry goods to meats and groceries. The "Maize and Blue" sign in the right window indicates a University of Michigan fan sold the ice cream, candy, and soft drinks. (Gary Byker Memorial Library.)

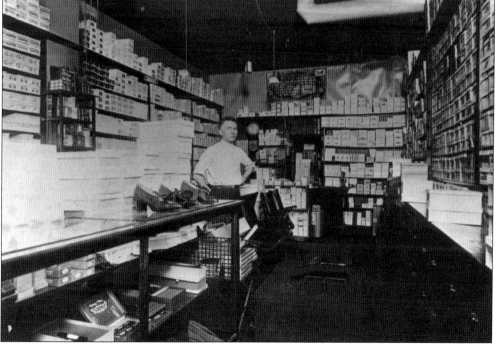

Robert Muller displays his wares in his downtown shoe store on Monroe Street in 1913. The company closed its last remaining store in the Breton Village Shopping Mall in East Grand Rapids in July 2008, ending a 95-year history. (Calvin College, Heritage Hall.)

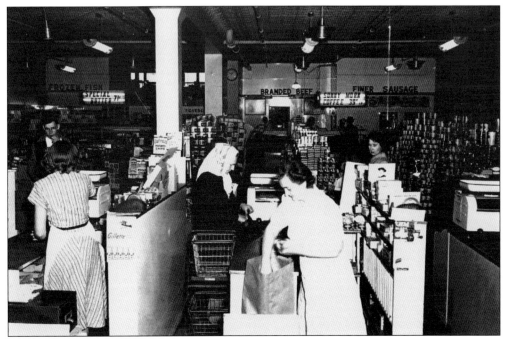

Larger and more convenient than the mom-and-pop neighborhood grocers, stores like Zeeland's Van Eenanaam's Grocery offered shoppers more variety and lower prices. George Van Eenanaam owned the market. Delia Van Eenanaam packs groceries; the boy at the left is Fred Klumpe. (Zeeland Historical Society.)

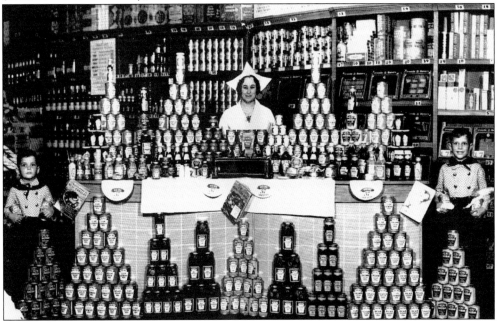

Jim and Art's Food Market, also in Zeeland, was located at Seventeenth Street and Central Avenue in 1932. The Heinz promotion is appropriate. Although the company was headquartered in Pennsylvania, cucumbers and other vegetables were grown in Ottawa and pickled in the company's Ottawa pickling station. (Zeeland Historical Society.)

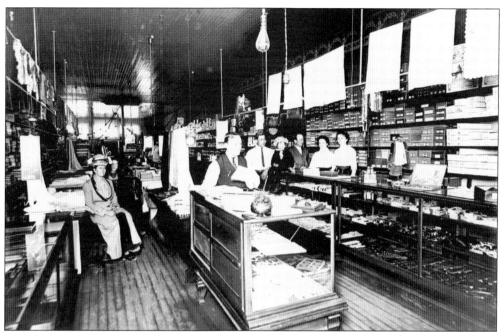

The Boone Store in Zeeland offered anything one could need in the way of dry goods. People shopped locally in those days, so there was ample room for other shopkeepers as well. One of those was Cornelius Steketee, who came to Holland with Albertus C. Van Raalte in 1847. The Steketee family remained in the retail industry, eventually founding the venerable Steketee's Department Stores, an area fixture in both counties until the last remaining store in Holland's Westshore Mall closed in 2003. (Calvin College, Heritage Hall.)

John De Young was keeper of the Grand Haven Life Saving Station from 1880 to 1885 before becoming a partner on a commercial fishing tug, the *J. W. Collister*. De Young (standing) and his crew are ready for a search or rescue mission. (Tri-Cities Museum.)

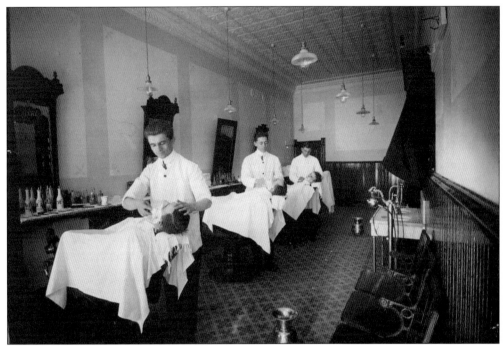

John Pieper (left) operated a barbershop at 135 Main Street, Zeeland, in the early 1930s. David Vereeke, center, learned the trade at age 16 and later bought the shop from Pieper. The third barber is Martin Wyngarden. Men congregated at the shop for shaves, haircuts, and the latest local gossip. (Zeeland Historical Society.)

Dick Andringa was born in Friesland, near the Zuider Zee in the Netherlands, in 1884, the first of three children born to Dirk and Dirkje Andringa. The family immigrated to the Jamestown area of Ottawa County during his childhood. He founded a local bank that is now the Byron Bank. (Andringa family.)

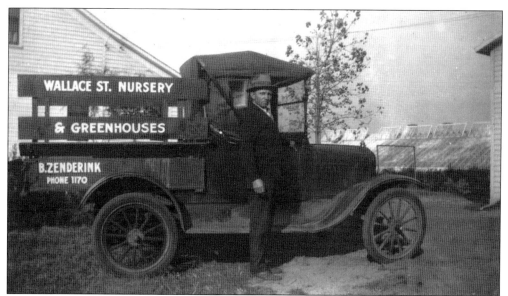

People were becoming increasingly interested in the exterior appearance of their homes and businesses, thus creating opportunities for landscapers like Ben Zenderink, who opened his Wallace Street Nursery and Greenhouses in 1919. He served on the Grand Haven City Council in the 1940s and sold his business to Joe Nelis of Holland in 1947. Nelis operated it until 1974. Zenderink was just one of many Dutchmen in the counties to operate greenhouses. (Tri-Cities Museum.)

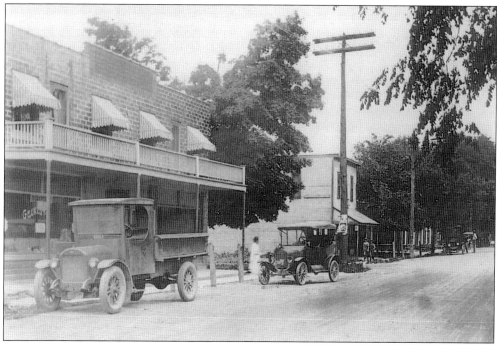

In 1910, Geukes Meat Market operated out of this building on Eighty-fourth Street in Byron Center. Now it is the home of Byron Family Restaurant, a local gathering place. (Ron Strauss.)

Edsko Hekman founded a commercial bakery that was once one of the three largest in the country. The man who did not speak English well enough to get a job as a janitor began his empire humbly, baking cookies for his children to sell door-to-door. When his son John broke ground in 1947 for a new Hekman Biscuit Company facility, those attending were the A list of local business elite. Seen below, from left to right are T. W. Hager, George Brandt, E. C. McCobb, Jelle Hekman, L. J. Thompson, Adrian Vanden Bout, C. O. Ransford, Sam Tamminga, H. M. Taliaferro, Gabe Hekman, A. T. McFadyen, J. R. Cassleman, George S. Clarke, Edward Hekman, N. J. Harkness, Eli D. Boes, D. W. Kimball, J. Browning, John Hekman (president, Hekman Biscuit Company), W. Dice, John Mieras, Ira Moore, Fred Krause, Peter Philips, Dwight Owen, W. W. Chamberlain, D. W. Steketee, C. J. Peterson, and W. Wichers. (Grand Rapids Public Library.)

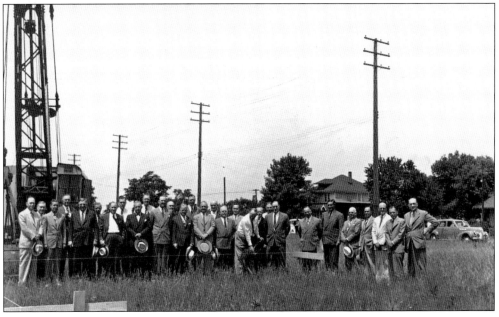

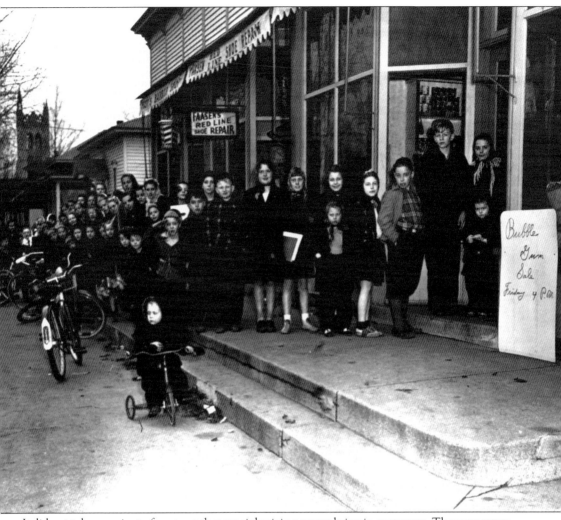

It did not take a genius to figure out that special pricing events bring in customers. The youngsters lined up in front of the Van Rys store on College Avenue in Holland are waiting for the 4:00 p.m. bubble gum sale. (Holland Museum.)

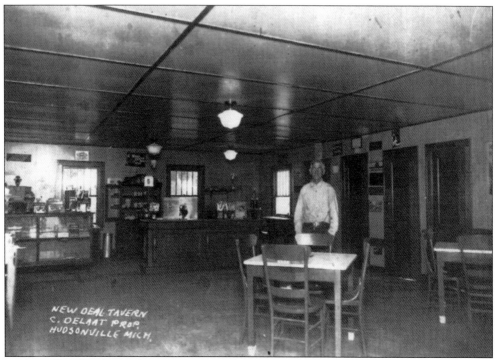

Hudsonville offered something cool to quench every taste. Those wishing to tip a cold one could do so at C. DeLaat's New Deal Tavern (above), while others with more temperate thirsts sipped their Cokes and malts at the soda fountain in the Yonker and Boldt emporium. (Gary Byker Memorial Library.)

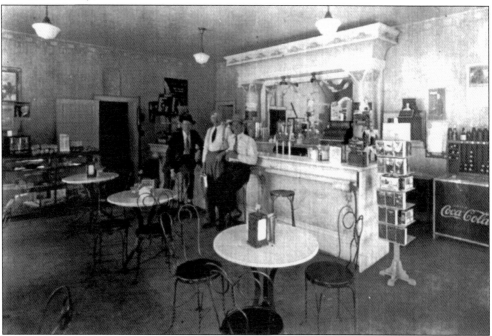

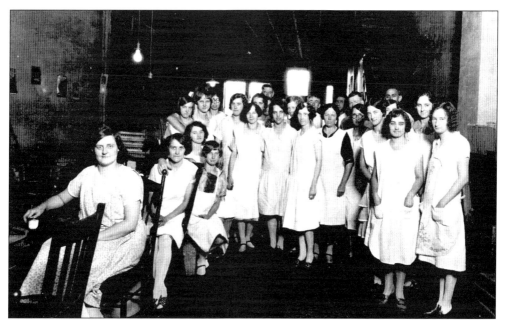

H. Van Eenanaam and Company Cigar Factory employees pose in 1927. The majority are women because they worked for a significantly lower wage. The women are identified as Jean Brouwer, Jean Kleinjans, Theresa Doorn, Hermina Boes, Hattie Blauwkamp, Syna Kraai, Hattie Van Rhee, Jessie De Jonge, Grace Elenbaas, Cornelia Dekker, Anna Dykema, Elizabeth Machiela, Grace Lankheet, Helen Van Rhee, Maggie Diepenhorst, Laura Brauwer, Anna Krol, and Margaret Elzinga. The men are, from left to right, Henry Van Hoven, John Komejan, Dan Vander Wege, John Northuis, and George Brandt. (Zeeland Historical Society.)

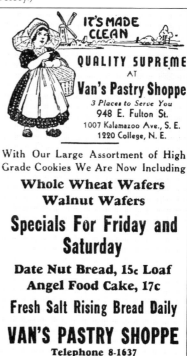

Van's Pastry Shoppe ran this advertisement in the *Grand Rapids Observer* on March 23, 1939, extolling quality and cleanliness. The bakery still operates at the Fulton Street location and retains a loyal following. Current owners are John and Donna VanderMeer. John's grandfather, also named John, started the business in 1928 with recipes he brought from the Netherlands. When he is not baking pastries, VanderMeer can be found playing the organ at the New Community Church of West Michigan. (Van's Pastry Shoppe.)

Russell Bouws opened his first restaurant in 1934 when he took over the former Doc's Barbecue. He changed the name to Russ', and it soon became a Holland tradition. When he learned his lot rent was being raised, he responded by moving the original building on Chicago Drive to 361 East Eighth Street. Seen here, from left to right, two unnamed movers, Gordon Bouws, and Russell Bouws prepare to hand-dig the basement in June 1947. (Russ' Restaurants.)

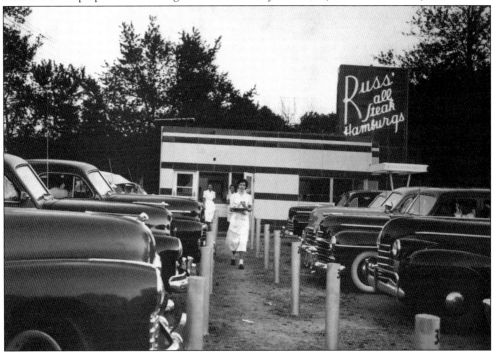

Today's teens flock to the malls. In earlier days, they found a favorite gathering spot to hang out and order curb-service shakes, burgers, and fries and at the same time build memories. In Holland that spot was Russ'. The curb service is long gone, but the food its still good and can be found in 10 locations in the two-county area with an additional two in Muskegon County. (Russ' Restaurants.)

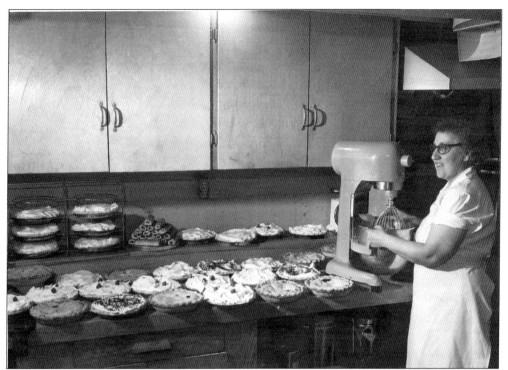

Homemade pies like the ones above have always been one of Russ's top sellers. Mom's apple pies might have been as good, but they were no better. (Russ's Restaurants.)

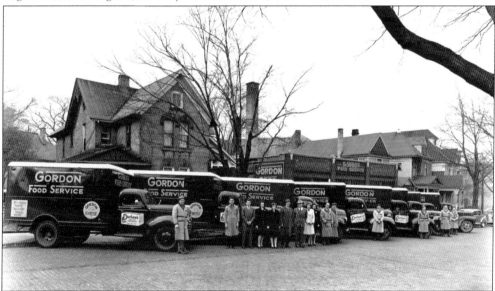

In 1897, Isaac VanWestenbrugge, the son of Dutch immigrants, borrowed $300 from his brother to start a business delivering butter and eggs to Grand Rapids grocers. Out of that grew Gordon Food Services, a company supplying the food service industry in the United States and Canada. In 1942, Isaac's son-in-law, Ben Gordon, and Frank Gordon formed a partnership and reorganized the company. Butter and eggs proved a good way to start, as Hudsonville Ice Cream and Koeze share those humble roots. (Gordon Food Service.)

Sibbele Koeze, shown with his first wife, Gezina, emigrated from Friesland in the 1880s and after working in the furniture factories established a wholesale butter, egg, and produce company. By 1925, he was handcrafting the peanut butter that made him a local legend. Koeze Crème-Nut Peanut Butter is still made the same way: only two ingredients that are slowly roasted and ground using vintage machinery from the 1950s. Albertus's grandson Jeff runs the Koeze Company today and still produces the same all-natural peanut butter along with other nut and candy products. (Koeze Company.)

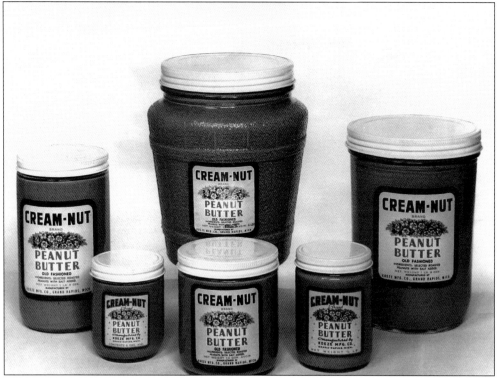

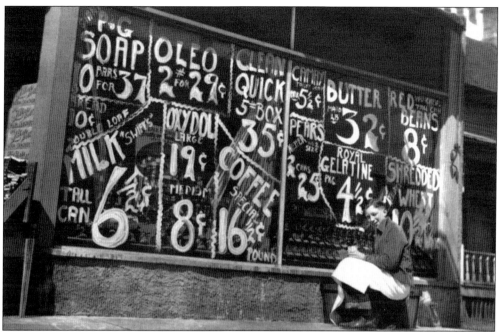

Hendrik Meijer would revolutionize shopping with his one-stop-shopping enterprises, but he first spent 22 years operating a barbershop. His first grocery measured only 21 feet by 70 feet and offered no credit accounts and no free deliveries. Meijer realized he had to discontinue those practices so he could offer more variety at lower cost to the consumer. He pioneered the one-stop-shopping concept with his Meijer Thrifty Acres superstores, now simply called Meijers and found throughout the Midwest. The photograph above shows a young Fred Meijer painting his father's store window. Below is a Meijer store icon, Sandy, a mechanical pony that children can still ride for a penny. (Meijer Corporation.)

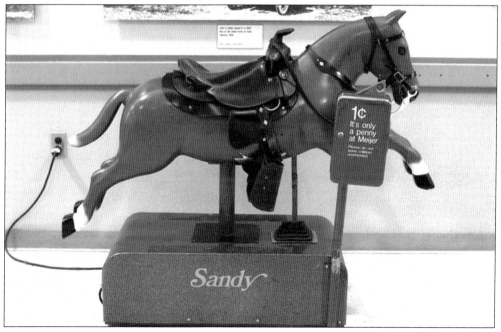

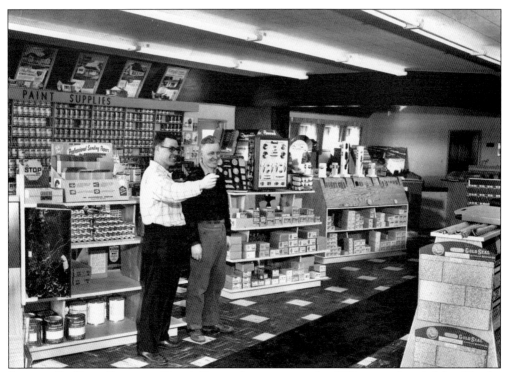

Rycenga Building Center, a Grand Haven fixture since the 1930s, was founded by Charles Rycenga. His sons Chuck Jr. and Louie took the helm following his death in 1941. Now in their late 80s and early 90s, both men still come into the office on most days, although their sons, Chuck III and John, are officially in charge. This interior image of the store shows how it appeared in the 1950s. (Rycenga Building Center.)

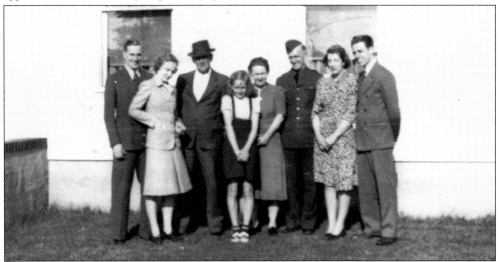

In July 1941, the Rycenga family posed informally for the last time. Just two months later Charlie Rycenga died in an accident, leaving his sons in charge of the business. From left to right are Roy Correll, Emma Rycenga Correll, Charlie Rycenga, Betty Rycenga Rodrigues, Sena Rycenga (Charlie's wife), Louie Rycenga, Non Kieft Rycenga, and Chuck Rycenga Jr. (Rycenga Building Center.)

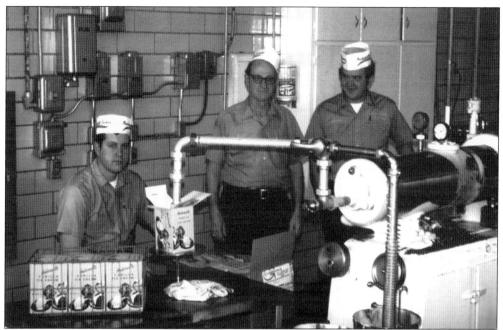

Other folks can have their Ben and Jerry's. For Michiganders the icy treat of first choice has long been Hudsonville Ice Cream. First known as the Hudsonville Creamery, the co-op began business in 1895 and made its first ice cream in 1926. Dick Hoezee bought out his partners in 1946 and later moved the company from the northwest corner of School Street and Prospect Avenue in Hudsonville to nearby Burnips when the original building was razed to make way for a double-lane highway. The company is now located in Holland and still churning out the same velvety ice cream. (Hudsonville Ice Cream.)

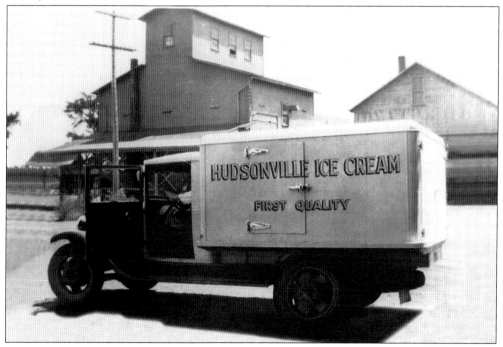

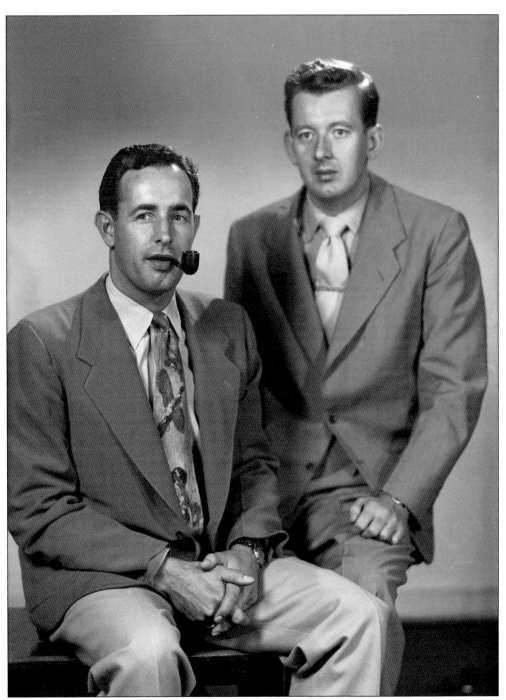

What would become an international company began in a southeast Grand Rapids garage by friends and entrepreneurs Rich De Vos and Jay Van Andel. Named Amway, short for the American Way, the corporation is now headquartered in Ada, and its products are distributed around the world. In 1981, the partners bought the aging Pantlind Hotel in downtown Grand Rapids, restored it to its former glory, and renamed it the Amway Grand Plaza. (Grand Rapids Public Library.)

Christian publishing giant Zondervan owes its existence to the William B. Eerdmans Publishing Company. When Eerdmans fired his young nephew, Pat Zondervan, the nephew and his brother Bernie started their own company. The new business started in the family's Grandville farmhouse shown above. (Zondervan.)

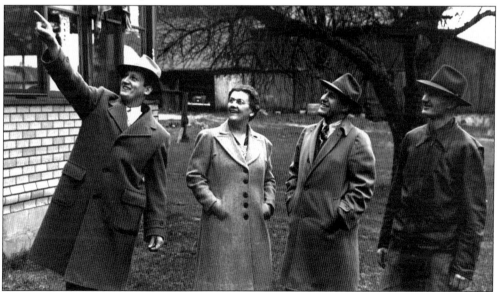

Bernie Zondervan (left) points to an upstairs bedroom that served as the initial corporate headquarters. From left to right, his mother, Petranella (Nellie), partner Pat, and father, Louis Zondervan Sr., share the moment. The company went on to publish Bibles, best sellers like *The Late Great Planet Earth* and *The Purpose Driven Life,* and books by Billy Graham and Johnny Cash, among others. In 2001, the company's electronic media department teamed with Phil Vischer and his popular Veggie Tales videos featuring a tomato named Bob and his sidekick, Larry the cucumber. (Zondervan.)

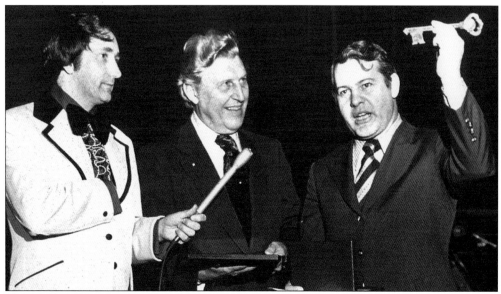

The Zondervan company remained true to its Christian roots. One ritual was a weekly chapel service for employees that often included outside clergy, speakers, and musicians. The brothers led the company through its phenomenal growth until Bernie Zondervan's death in July 1966. He had decided to anonymously give an organ to Calvin College's new Knollcrest campus. The family honored his pledge but dedicated it as a memorial to him. That kind of generosity, along with respected business practices, led Pat to receive a key to the city of Grand Rapids on P. J. Zondervan Day in 1973. Patrick Barr (right) makes the presentation, while at left, emcee Dick Hatfield looks on. (Zondervan.)

People were not told to "follow your bliss" way back then, but it appears that Dan Pfeiffer did just that. His early interest in vehicles translated into a lifelong career as a new car dealer. (Byron Center Historical Society.)

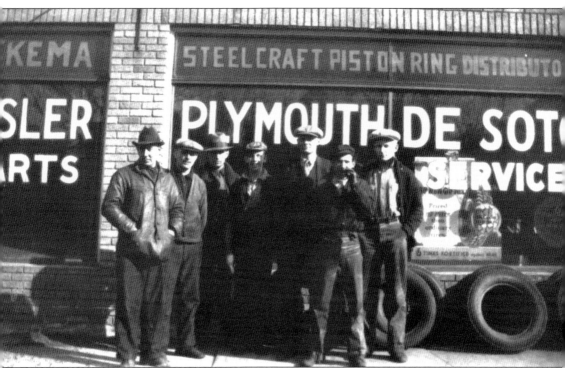

The Van Andel and Flikkema dealerships began as a Dodge truck repair shop. Soon the partners decided to also sell used cars as well as service them. In autumn of 1932, they bought this building at 732 Lafayette Street. In 1948, they became a Tucker dealer, but the manufacturer closed after producing only 51 vehicles. In 1950, they bought a De Soto Plymouth dealership on Plainfield Avenue where they continue in business today. Pictured left to right are James Van Andel, John Flikkema Sr., George Flikkema, Herb Ackerman, Peter Flikkema, Aran Steele, and Joe Danhof. (Van Andel and Flikkema Motors.)

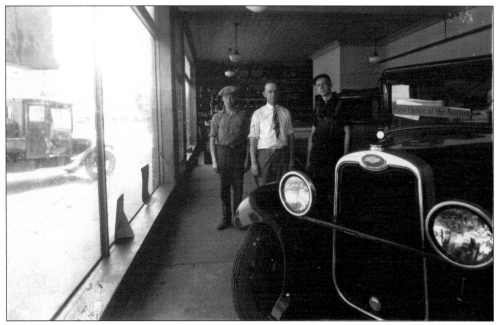

Bert Lemmen started his business in Allendale about 1905. Soon after, he relocated to downtown Main Street in Coopersville. Pictured with a vintage Chevrolet, from left to right are John Meerman, Bernie Lemmen, and Symon Vander Ploeg. (Robert Lemmen.)

Automobile dealership families celebrate at a Christmas event. From left are John Borgman, Fred Betten, Joe Duthler, Dennis Betten, Patricia Duthler, ? Keller, Jack Keller, and Red Betten. (Tony Betten Ford.)

Four

CHURCHES AND SCHOOLS

Because the Dutch left their homeland to escape government interference in their religious practices, it is understandable that faith was the core of their new lives in Michigan. Before they built Dominie, Albertus Van Raalte's first Holland Church, the settlers gathered for lengthy worship services in the snow.

The original kolonie soon aligned itself with the Reformed Church of America, already flourishing in the Dutch-settled regions of New York. Differences of opinion led to some members leaving the denomination to found the Christian Reformed Church and other Calvinistic denominations that varied slightly from the Reformed Church of America. That legacy in the two counties is vast and ongoing. Today, more than 123,000 members belong to over 280 churches that still represent a strong Calvinistic world view and Protestant work ethic.

Believing that parents, not the state, have primary responsibility for educating their children, they established parent-controlled primary and secondary schools. At present, approximately 15,000 students attend nearly 300 private Christian schools. This custom began when Albertus Van Raalte founded Hope College in Holland.

Western Seminary followed Hope College in Holland. Currently, more than 3,000 students attend Hope, with nearly 250 in the seminary. In Grand Rapids, Calvin College (current enrollment 4,200) and Calvin Seminary (300 plus) opened their doors in 1876. Kuiper College (first called Reformed Bible College) was established in 1940 in Grand Rapids, and has more than 300 students.

The immigrants' respect for education shows in other ways as well. The Calvin College library is named for Edsko and Claire Hekman, whose support helped make it a reality. Most buildings in all three colleges bear the Dutch names of educators and contributors who left an indelible mark on the schools, and whose legacies live on.

Rev. Albertus C. Van Raalte served as pastor of the colony's first church from 1847 to 1867. In 1882, the congregation withdrew from the denomination and joined the Christian Reformed denomination. Still a Holland landmark, it is now known as the Pillar Christian Reformed Church. The Packard suggests this image may have been taken around 1940. (Holland Museum.)

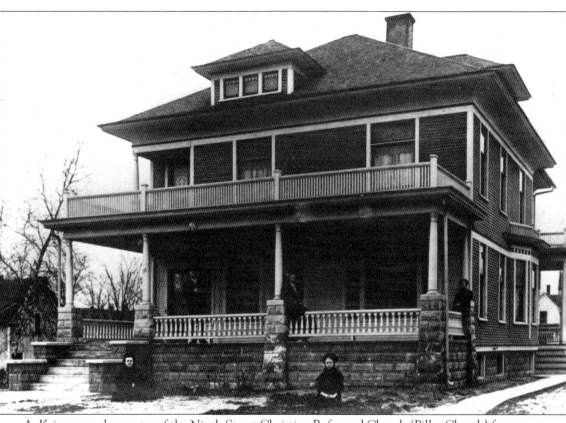

A. Keizer served as pastor of the Ninth Street Christian Reformed Church (Pillar Church) from 1902 to 1910 and is shown here on the porch with his family. (Calvin College, Heritage Hall.)

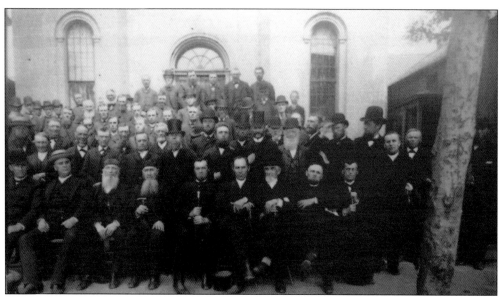

These gentlemen were members of the 1881 synod, the highest body of the Christian Reformed Church, and have the distinction of posing for the denomination's first photographic record of any synod. The image was taken in Grand Rapids. (Heritage Center, Graapfschap Christian Reformed Church.)

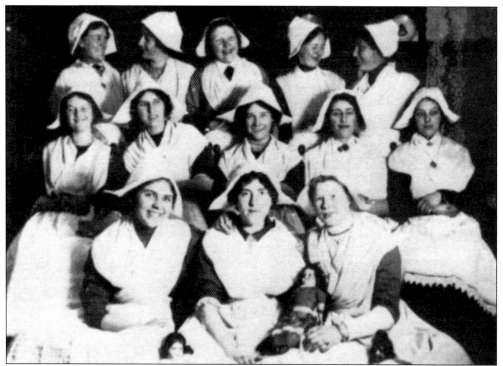

Although the church does not govern Christian schools, its members are deeply committed to them. These young ladies from the Second Reformed Church in Grand Haven were ready to call on members in hopes of receiving a 25¢ monthly donation to help support their school. This photograph was taken around 1913. (Second Christian Reformed Church.)

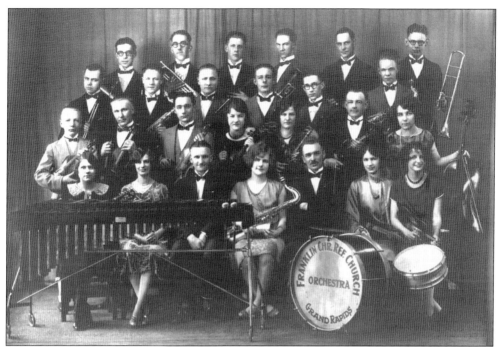

Franklin Street Christian Reformed Church in Grand Rapids had an orchestra complete with a xylophone in the 1920s. (Calvin College, Heritage Hall.)

Six First Reformed Church friends pay tribute to their heritage in this undated photograph. From left to right are (first row) unidentified, Clara Madderom, and ? Heiftj; (second row) ? Wesenbroek, R. Raak, and unidentified. (Zeeland Historical Society.)

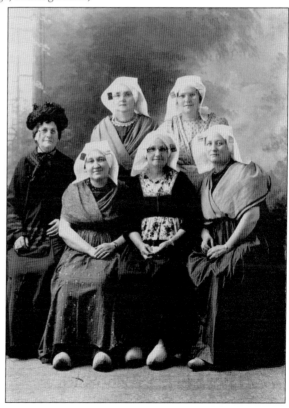

The Old Dutch Church on Spring Street (now Commerce Avenue) was used as the city social center and provided housing to those in need during the depression in the 1930s. (Calvin College, Heritage Hall.)

The United Reformed Church bought this sanctuary on the southwest corner of 100th Street and Division Avenue from the Corinth Reformed Church when Corinth moved to its new campus on the northeast corner. Friendship Christian Reformed occupies the southeast corner. Found within five miles are Immanuel Reformed Church and First Reformed. The Christian Reformed denomination weighs in with First Christian Reformed (Cutlerville), First Christian Reformed (Byron Center), Second Christian Reformed, Hillside Christian Reformed, Providence Christian Reformed, Covenant Christian Reformed, Pathway Christian Reformed, and Heritage Christian Reformed. There is also a Protestant Reformed church. (Jay de Vries.)

Although some outsiders see the ethnicity of the Dutch churches as insular, reaching out to others both in the community and in the world at large has always been an important part of the ministry. Here the South Olive Christian Reformed Church welcomes migrant farmworkers. (Calvin College, Heritage Hall.)

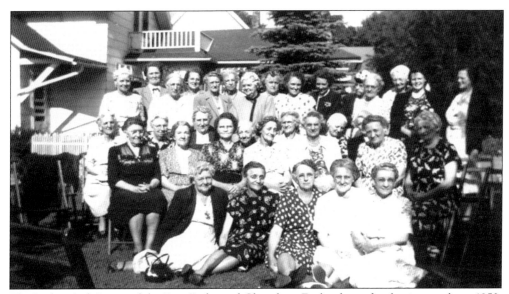

The Ladies Aid Group of the First Reformed Church in Zeeland met for this image about 1950. Identified here are Sadie De Kraker, Mattie Van Bronkhorst, Gertie Sneller, Mrs. John Yntema, Fannie Van Pels, Mrs. J. Van Duine, Delia Smidderks, Hattie Pikaart, Berta Vredeveld, Anna Borr, Clara Madderom, Mrs. Kuiper, Rose Fris, Bertha Staal, Anna Huizenga, Jennie Bouma, Elizabeth Hieftje, Mrs. Welling, Mrs. Diepstra, Anna Westenbroek, Nancy Kaat, Henrietta Gebben, Anna Kaper, Mrs. Hartgerink, Martha Karsten, Mrs. Abraham Rynbrandt, Mrs. Simon Elhart, Helen Van Duine, Frances Fox, Mrs. De Hoop, and Mrs. Gerrit Walters. (Zeeland Historical Society.)

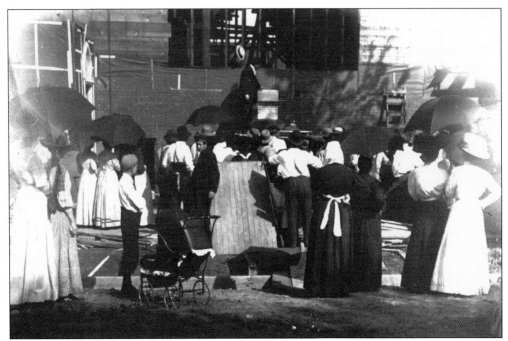

Members of the Eastern Avenue Christian Reformed Church gathered to observe the laying of the cornerstone for a new building in 1913. Note the Dutch apron and cap on the woman in black. Other ladies use parasols to protect their complexions. (Calvin College, Heritage Hall.)

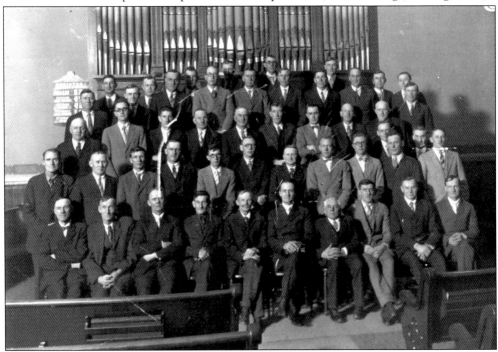

The men's society (Sons of the Pioneers) met for Bible study. This group of Drenthe Christian Reformed Church members was photographed in front of the church's pipe organ in 1928. (Calvin College, Heritage Hall.)

This Reformed church was built in Vriesland, Michigan, in 1869 but was actually organized at Leewaarde, Netherlands, in October 1846, and like the other Dutch settlers, the congregation came to America to flee religious persecution. (Vriesland Reformed Church.)

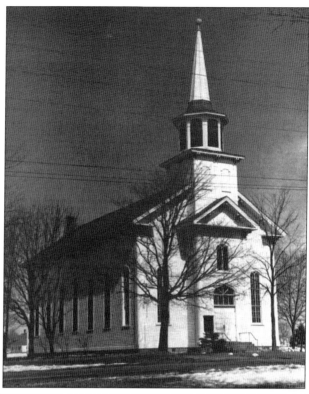

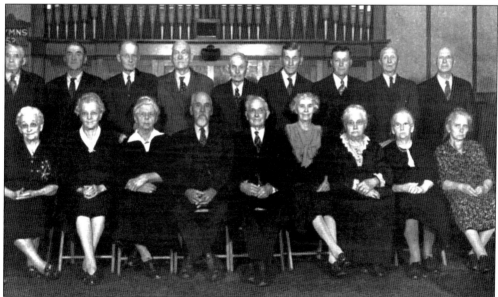

The Vriesland church celebrated its centennial in 1947. Pictured here are members who were then 70 years or older. From left to right are (first row) Mrs. E. Ver Hage, Mrs. T. W. Van Haitsma, Mrs. S. Boss, S. Boss, J. G. J. Van Zoren, Mrs. J. G. J. Van Zoren, Mrs. H. J. Vander Kolk, Mrs. E. Vander Kolk, and Mrs. D. Schermer; (second row) E. Ver Hage, J. Bakker, S. Broersma, B. Kroodsma, D. C. Ver Hage, G. De Hoop, P. De Hoop, T. W. Van Haitsma, and G. De Vree. (Vriesland Reformed Church.)

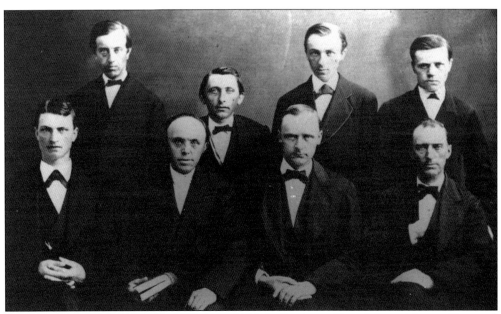

These gentlemen comprised the 1877 class of Calvin Seminary. From left to right are (first row) J. Vander Werp, Prof. G. Boer, C. Bode, and C. Vorst; (second row) G. Hoeksema, G. Broene, H. Tempel, and H. Douwstra. (Calvin College, Heritage Hall.)

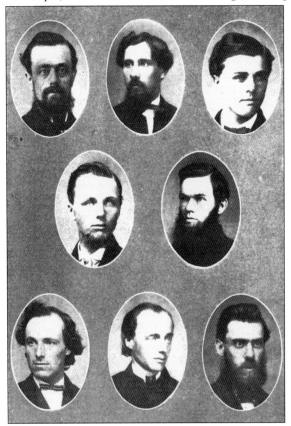

On July 17, 1866, Hope College celebrated its first commencement with eight graduates. From left to right are (first row) ? Buursma, W. Woltman, and G. Dangremond; (second row) W. Moerdyke and J. W. Te Winkel; (third row) W. B. Gilmore, W. A. Shields, and P. Moerdyke. (Joint Archives of Holland.)

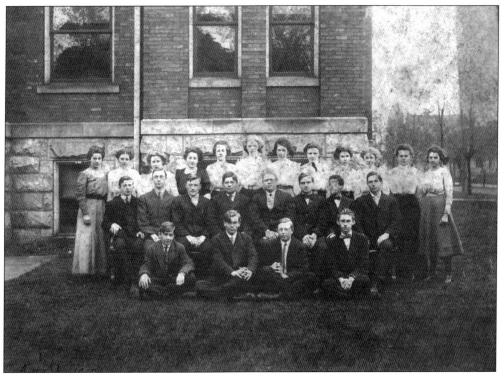

Hope College's 1930 graduating class poses in front of the Van Raalte Hall entrance. Dr. Wynand Wichers replaced Edward Dimnent as president of the college the following year and served for 15 years. (Joint Archives of Holland.)

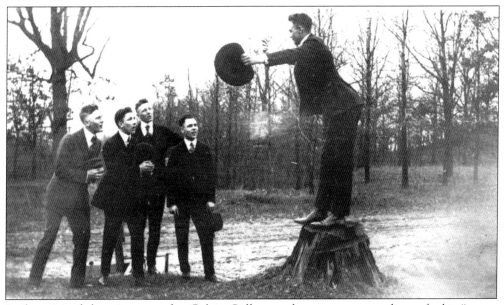

In the spirit of clowning around, a Calvin College student attracts an audience for his "stump speech" on the campus in 1919. (Calvin College, Heritage Hall.)

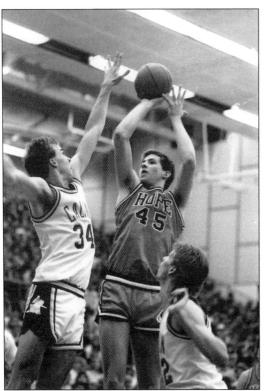

The Hope College and Calvin College basketball teams go at it again. The rivalry, pronounced the best in the NCAA Division III by ESPN and written up in *Sports Illustrated,* began in the 1920–1921 season with Hope winning 31-13. Former Hope College president Calvin vanderWerf once defined an atheist as "someone who doesn't care who wins the Hope-Calvin basketball game." After 171 games, as of February 2009, Hope has a one-game and 166-point edge. (Calvin College, Heritage Hall.)

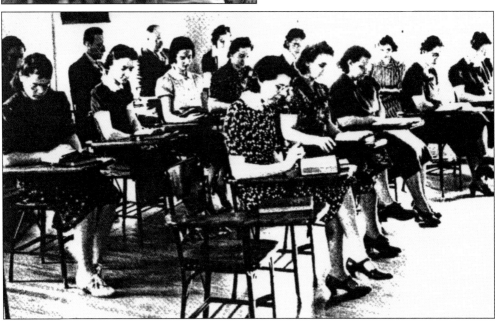

Kuyper College opened in Grand Rapids as the Reformed Bible Institute in 1940. Its purpose was to educate prospective workers in evangelism and missions from a Reformed understanding of scripture. By 1968, the name changed to Reformed Bible College as academic classes were added and students could obtain an accredited bachelor of religious education degree. A 1940 class is pictured above. (Kuyper College.)

An annual Kuyper International Invitational Golf Scramble benefits the International Student Scholarship Fund. The player making the longest putt is awarded the Ben Boersma Commemorative Putter. The handcrafted putter reflects the message, symbolism, and appearance of the school's Vos Chapel Unity Communion Table. (Kuyper College.)

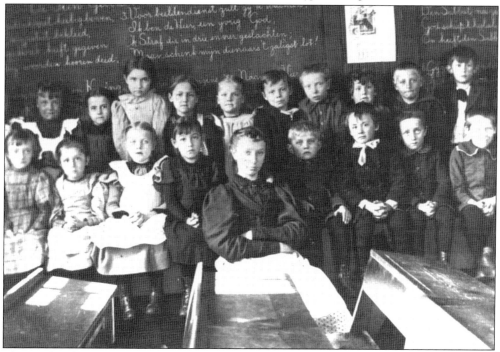

This undated photograph at the Alpine Avenue Christian School shows the difficulty of assimilation into American culture. The children spoke English in school, but here the Ten Commandments are written on the blackboard in Dutch. (Calvin College, Heritage Hall.)

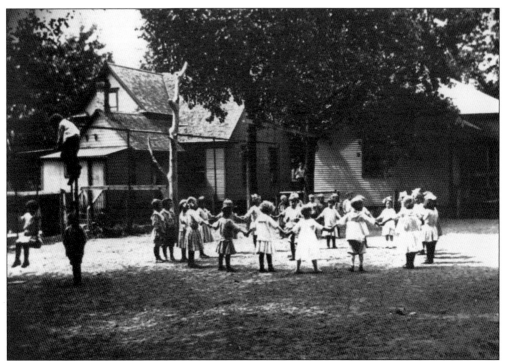

Scenes like this occurred on every school playground in the country in the early decades of the 20th century. Most of the children are playing a circle game (perhaps Farmer in the Dell) while a few holdouts opt for the playground equipment. The action here took place at the Holland Christian School. (Calvin College, Heritage Hall.)

Leisure activities for teens tended to be wholesome, such as the hotdog roast shown here, with movies and dancing once frowned upon, both by parents and by the church. The restrictions applied to adults as well as young people. A joke from a 1950s issue of the church magazine *The Banner* said it all. "Question: Why are Christian Reformed couples not permitted to make love standing up? Answer: It might lead to dancing." (Calvin College, Heritage Hall.)

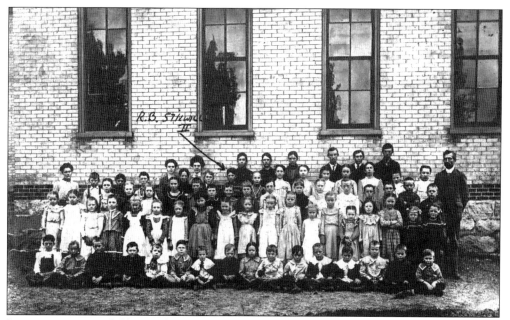

Jamestown was justifiably proud of its fine new brick school building when the faculty and student body posed outside in the 1920s. (Patmos Library.)

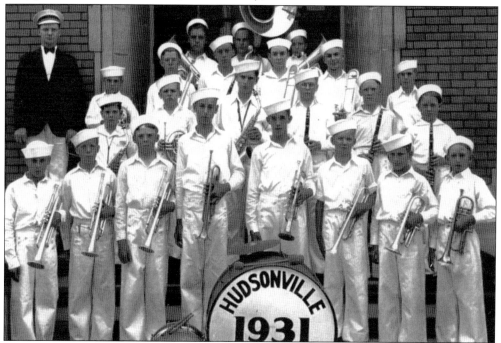

The Hudsonville High School Band of 1931 stands ready to play. Identified here are Harold Kole, Joe DeVries, John Schuitema, Harvey VanDam, Wilson Drew, Harold Ver Hage, Max Lowing, Edward DeWeerd, Henry Moes Jr., Gene Cory, Edson Nyhuis, Tom Cory, Casey Schuitema, Robert Van Noord, Bert Brandt (director), Gene Nyhuis, Alvin Ringerwole, Clarence DeWeerd, Bernard Vugteveen, Jim DeWeerd, Vern Huyser, and Grant Edson. (Gary Byker Memorial Library.)

Giving their children a Christian education has always been important in the Christian Reformed denomination. These teachers from the Alpine and Pine Avenue Christian Schools relax for the camera before the dawn of the 20th century. (Calvin College, Heritage Hall.)

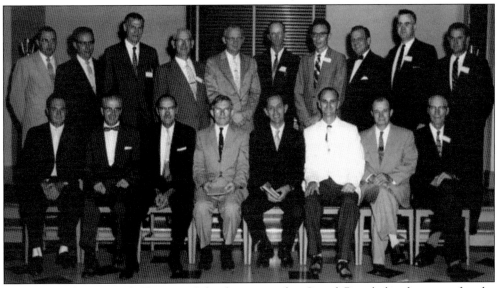

The National Union of Christian Schools met at the Grand Rapids headquarters for the October 1959 board of directors meeting. The organization is now called Christian Schools International. Shown from left to right are (first row) Dr. Robert Paxton, Harvey Brasser, Dick Talsma, Dr. Bert Bos, Harold Camping, J. A. Van Ark, George Rooy, and Egbert Meyer; (second row) Robert Guise, William Leys, Walt Hommes, H. J. Ter Hove, Clarence DeBoer, Cornelius VerBrugge, Ivan Zylstra, Henry Hoekstra, Albert Greene, and Gerrit VandePol. (Christian Schools International.)

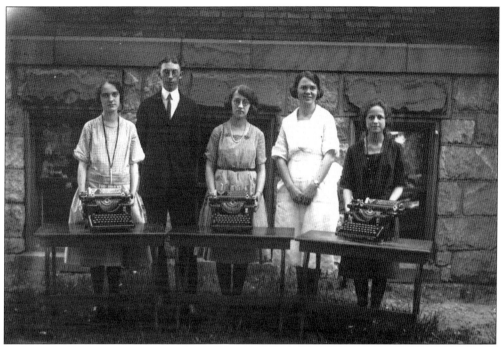

In the early 1920s, typing was a useful skill for young women entering the workforce. These high school students won a Grand Rapids Christian High School Typing Contest and are shown with their typewriters. From left to right are Renze Dornbush, ? Goenveld, Alethe Wyngarden, Alyda Hoekman, and unidentified. (Calvin College, Heritage Hall.)

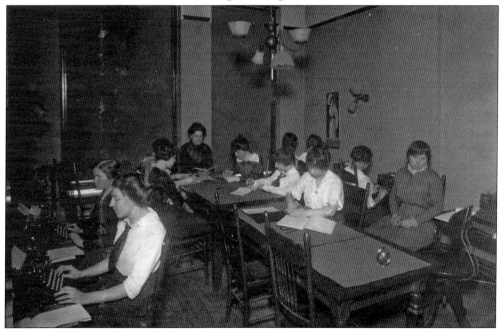

Following high school, young ladies in Grand Rapids could increase their chances of employment by learning additional office skills at the Van Wyck School of Shorthand. (Grand Rapids Public Library.)

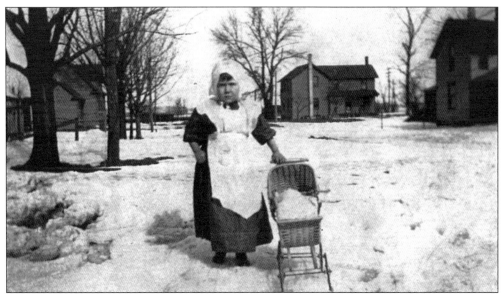

Taking her doll for a winter stroll appears to be serious business for Norma Alward of Hudsonville. The three year old is dressed in the manner of girls in the Netherlands in 1915. By her 1927 eighth-grade graduation, she is as stylish as any small-town American girl. Seen below, from left to right, are (first row) Ella VandeBunte, Gladys DeNeff, Mabel Kiel, Norma Alward, and Dorothy VanderMollen; (second row) unidentified, Ethel DeVree, Ida Hall, Ken VanHeukelum, and Melvin Hoezee; (third row) Ray Meyer, Clyde VandeBunte, Dan Gryzen, Gibb Hall, Grant Peasley, and Ben Haan. Norma Alward later married Ken VanHeukelum, who is standing just behind her. (Gary Byker Memorial Library.)

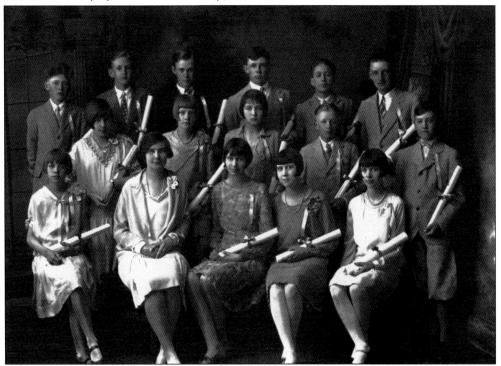

Five

THE DUTCH AMERICANS

The immigrants assimilated into the American mainstream without compromising the character of their culture. They zealously bought into the "idle hands are the devil's workshop" theory but almost never worked on Sundays. The Ottawa tribe of Native Americans in the area had been converted to Christianity by missionaries and became offended when the Van Raalte settlers moved their goods down the Black River on Sundays.

In their limited leisure hours they enjoyed picnics, ball games, and church socials, among other activities. They treasured books and encouraged their children to read. Children were permitted card games as long as the game was Rook or another game that required no face cards. Rainy days on the farm brought unexpected welcome days of leisure. Sometimes the line between work and play is indistinct. Major-league baseball player Jim Kaat once refused to play a Sunday game. The Zeeland-born pitcher joined the Washington Senators as a free agent in 1957, after his freshman year at Hope College, and finished his career with the St. Louis Cardinals in 1983.

Although they usually married within their cultural communities to keep their customs alive, they participated in the community at large. They served honorably in every war since the Civil War. Past and present political leaders of Dutch descent include United States senator Arthur Vandenberg, along with Congressional representatives Bartel Jonkman, Richard Vander Veen, Guy VanderJagt, Vernon Ehlers, and Netherlands-born Peter Hoekstra. Terry Lynn Land was elected Michigan secretary of state in 2002 and reelected in 2006.

The Dutch distinguished themselves in the arts. Newbery Medal–winning children's author Meindert DeJong was a Grand Rapids native, as is two-time Caldecott Medal–winning Chris Van Allsburg of *Polar Express* fame. Noted bacteriologist and science author Paul de Kruif was born in 1890 in Zeeland. Reynold H. Weidenaar is best known for his intaglio techniques as well as watercolors and oils. His work is in many museums, including New York's Metropolitan Museum of Art. He taught for more than 20 years at the Kendall School of Design in Grand Rapids. Along with their business and industry endeavors, the Dutch successfully entered the professions as doctors, lawyers, accountants, clergy, and educators.

By 1900, the Dutch comprised the largest ethnic group in the Grand Rapids area, 23,000 of 87,000 total, or 27 percent. Ottawa County was still predominately Dutch.

Jan Hendrik Boone is on Paw Paw Drive in Holland in front of the golf course caretaker's house. Even hardworking Dutchmen managed to find the time for a round of golf in the 1880s. (Calvin College, Heritage Hall.)

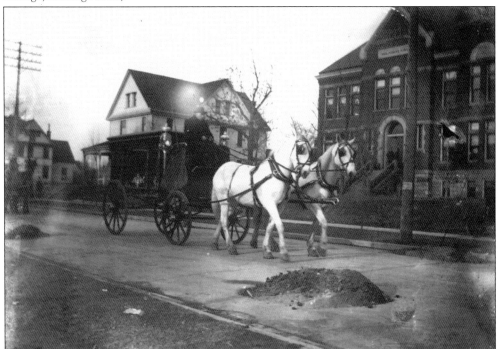

A horse-drawn funeral cart carries the body of Gerrit Boer, proceeding down Franklin Street in front of the original building of the theological school of the Christian Reformed Church in the early 1890s. (Calvin College, Heritage Hall.)

This fine carriage and pair of matched horses were elegant enough to be called an early Graafschap taxicab. (Heritage Center, Graafschap Christian Reformed Church.)

Bacteriologist and science writer Paul de Kruif, shown above with his mother, Anna, was born in Zeeland in 1890. He authored 25 books, including the best-selling *Microbe Hunters*, and contributed science and medical articles to leading magazines. Although his name is not on the cover, he assisted Sinclair Lewis in writing the novel *Arrowsmith* by providing the scientific and medical information and received 25 percent of the royalties. (Zeeland Historical Society.)

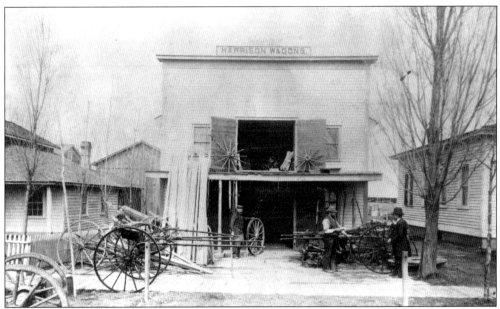

Horses and carriages were still the order of the day when this carriage shop was photographed in Graafschap around the dawn of the 19th century, but soon were used by physicians such as Zeeland's Dr. John Masselink. The doctor was known to carry a basket of food along with his medical bag when making a house call to a poor family. (Calvin College, Heritage Hall.)

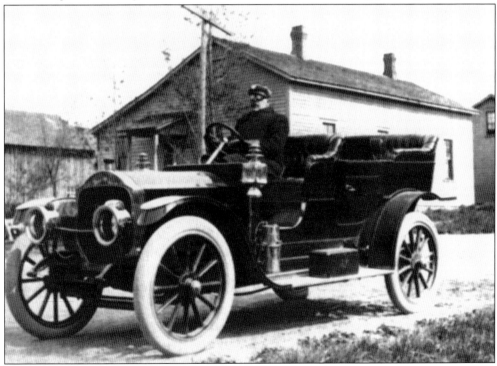

Graafschap's Dr. Bernadus Beuker's horseless carriage made for easier transportation in 1910, but the work was still difficult, with frequent frustration and occasional heartache. (Heritage Center, Graafschap Christian Reformed Church.)

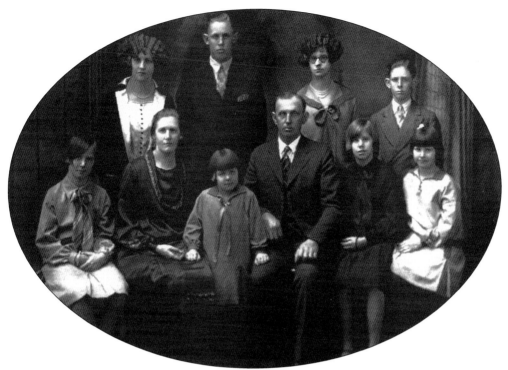

Large families were the norm, particularly in the farming communities where all hands were needed, and the Ringerwole family of Jamestown in Ottawa County was no exception. From left to right are (first row) Myrtle, Helena, Hazel, Henry, June, and Rosa; (second row) Bertha, Alfred, Margaret, and Ray. How long did it take the older daughters to create those hairdos?

There was no need for fancy entertainment when activities as simple as ice-skating provided so much pleasure. These folks enjoy a winter outing at the Eastern Avenue Christian Reformed Church in Grand Rapids in the 1880s. (Calvin College, Heritage Hall.)

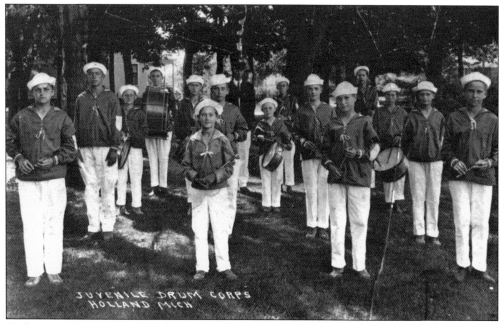

With seemingly never-ending chores, music proved a welcome diversion for both for the listeners and the performers. The Holland Juvenile Drum Corps members line up with their fifes and drums around 1910. (Calvin College, Heritage Hall.)

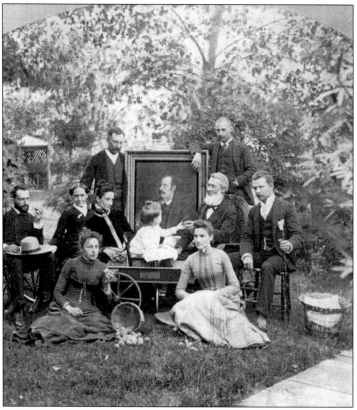

Rev. Philip Phelps Jr. was elected first president of Hope College in 1865 and served until 1880. Phelps is shown standing on the left, and in the framed portrait, surrounded by his family. (Holland Museum.)

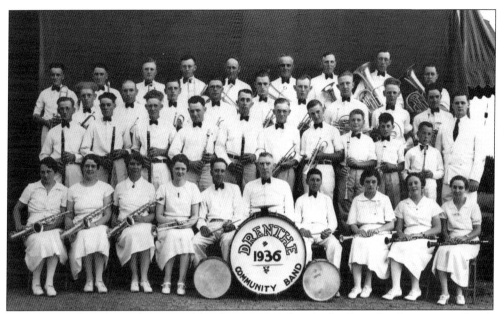

By 1936, bands welcomed women, like these pictured with the Drenthe Community Band. (Calvin College, Heritage Hall.)

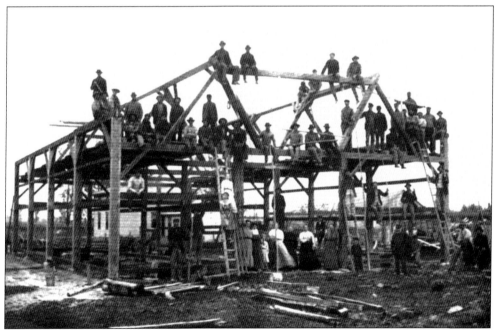

Although hard work for all involved, barn raisings were great social events as well. Women prepared and served vast quantities of food but also had the opportunity to catch up on what was going on in the lives of their friends and neighbors. For the children it was an all-day picnic with fun for all. These people have gathered to raise a barn for the John Bouws family in 1912. (Zeeland Historical Society.)

Dirk Van Raalte is seen with his children Dirk II and Albertus. After losing his right arm when wounded in Atlanta during the Civil War, Albertus C. and Christina Van Raalte's younger son returned to Michigan and served in local and state politics. He married Kate, the daughter of Holland's first mayor, Dr. Bernardus Ledeboer. (Holland Museum.)

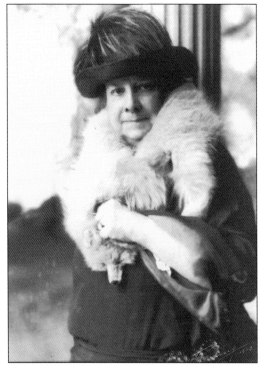

In her later years, "Grandma" Kate Ledeboer Van Raalte was quite the fashion plate in her foxes and high-style chapeau. (Holland Museum.)

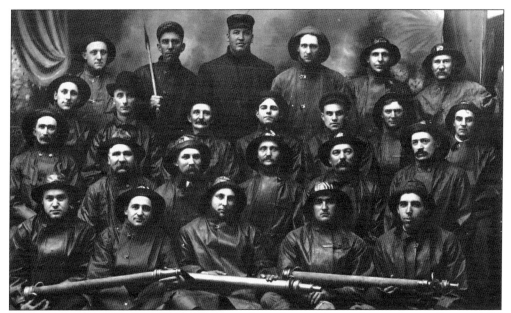

These Zeelanders protected life and property from flames. From left to right are (first row) Ed Hendricks, Simon Bouwens, Bert Wiersma, William Hieftje, and Isaac Van Dyke; (second row) Gerrit Hieftje, Johannes Pyle, Dr. Heasley, James Cook, Jacob Meyboer, and M. C. Verhage; (third row) William Wentzel, William De Pree, John Schipper, Martin Korstanje, Cornelilus DeKoster, Timon Vis, and Loyuis Thirston; (fourth row) Dick Boonstra, Henry Mulder, Bert Van Dyke, John Bouma, Gerrit Van Dyke, and Frank Huisenga. (Zeeland Historical Society.)

Lawrence Vanden Berg and his family sat for a formal portrait in Grand Haven in the early 1900s. He was one of the city's early movers and shakers, serving as superintendent of schools and as a city alderman. (Tri-Cities Museum.)

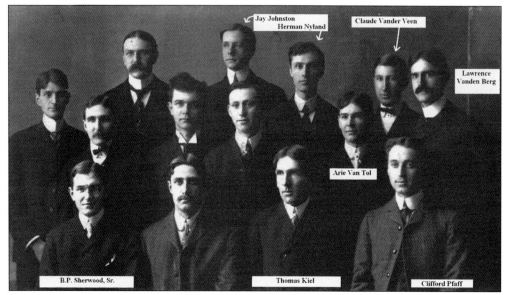

Jay Johnston
Herman Nyland
Claude Vander Veen
Lawrence Vanden Berg
Arie Van Tol
B.P. Sherwood, Sr.
Thomas Kiel
Clifford Pfaff

These Grand Haven gentlemen, including Lawrence Vanden Berg from the preceding page, are thought to be the charter members of the Stag Club, organized in Grand Haven in 1902 for the purpose of doing good works in the community. (Tri-Cities Museum.)

Jan Willem Garvelink of Graafschaap was born near Doetinchem, Gelderland, in the Netherlands in 1833. The immigrant family operated Garvelink Brothers Logging. He was elected to represent the Eighth District in the Michigan congress in 1873, becoming the second representative from the kolonie. He went on to serve as state senator, helped supervise the building of the Michigan State Capitol in Lansing, and served on the board of trustees of the John Calvin Theological School, now known as the Calvin Theological Seminary, an impressive list of accomplishments for a man with no formal education. (Heritage Center, Graafschap Christian Reformed Church.)

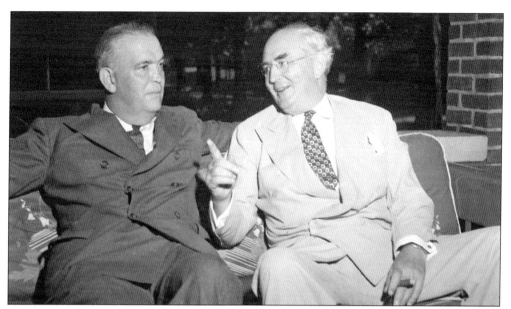

Michigan governor Harry F. Kelly (left) and United States senator Arthur Vandenberg confer on the front porch of Vandenberg's home at 316 Morris Street SE in Grand Rapids. It was said they discussed state, national, and international issues. The esteemed senator served from November 6, 1928, until his death from cancer on April 18, 1951. (Grand Rapids Public Library.)

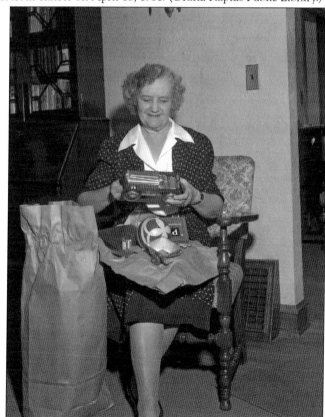

Prior to his political career, Vandenberg published the *Grand Rapids Herald*. Santa Claus Girls, a Grand Rapids volunteer group that provides toys and gifts to underprivileged children, was spearheaded in 1908 by Adriana VanDoorn with the support of Vandenberg and the *Grand Rapids Herald*. (Grand Rapids Public Library.)

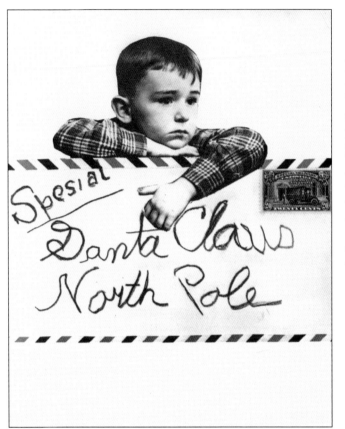

After asking children to mail their Santa Claus letters to the newspaper, Adriana VanDoorn visited the homes and gave the lists to their parents. When families could not afford to buy gifts, VanDoorn and her army of volunteers granted as many wishes as possible. The first year's cash and merchandise donations came to more than $200. Local automobile dealers lent four cars to deliver gifts to the homes of 150 children on Christmas Eve, as seen below. The *Grand Rapids Press* continues the tradition and along with individual contributors, churches, schools, businesses, and social and service organizations still makes children's Christmas wishes come true. (Grand Rapids Public Library.)

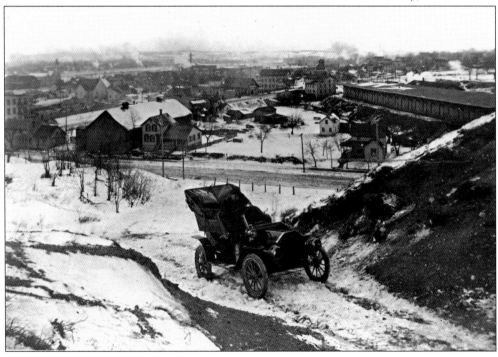

Two young Zeeland women pose at the spinning wheel in Zeeland in the 1920s. Already the Dutch heritage was recognized as something unique to the area and to be celebrated and preserved. (Calvin College, Heritage Hall.)

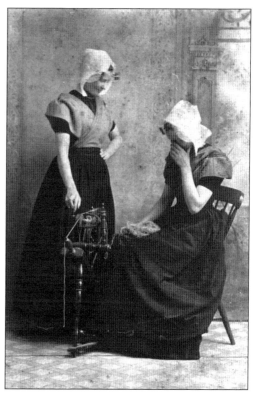

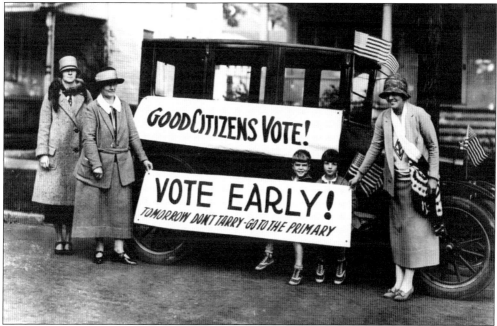

Mrs. Julius Amberg (right), president of the League of Women Voters, works at getting out the vote in the Grand Rapids 1924 primary. Seated are her children David and Mary Amberg. At left are Florence Shelley and Grace Van Hoesen, executive secretary of the league. (Grand Rapids Public Library.)

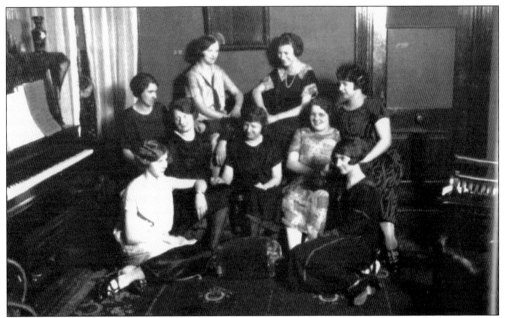

It has been said that "girls just want to have fun." Friendships were important, and women appreciated social events that gave them a break from their usual routines. J. Brill, the daughter of Peter and Margaret Brill, enjoys an evening of singing with her friends at her 142 Church Street home in Zeeland. From left to right are (first row) C. Johnson, S. De Kraker, Brill, E. Klinge, and A. Rummelt; (second row) K. Shoemaker, M. DePree, M. Vanden Bosch, and P. Lamar. (Zeeland Historical Society.)

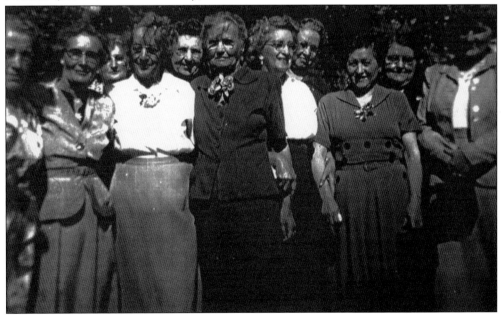

Another group, this one in Hudsonville, celebrates the importance of women's friendship. From left to right are Blanche Stenger, Marie Branch, Bertha Huyser, Alice Vander Boegh, Josie (Yonker) Boldt, unidentified, Myrtle Hubbard, Mabel (Boldt) Meyer, Hazel DeWeerd, Doris (Edson) Nyhuis, and Henrietta (Telgenhof) Cory. (Gary Byker Memorial Library.)

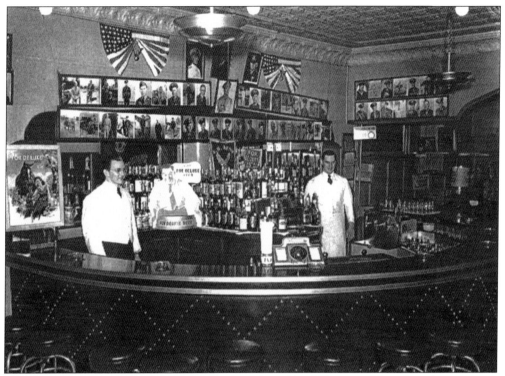

Boys might have preferred having fun at the Silver Cloud Tavern, although in later years it evolved into a place a fellow might bring his best gal for an evening of cocktails and dancing. The owners, George Broekema (left) and his brother John are seen here promoting Fox Beer. (Grand Rapids Public Library.)

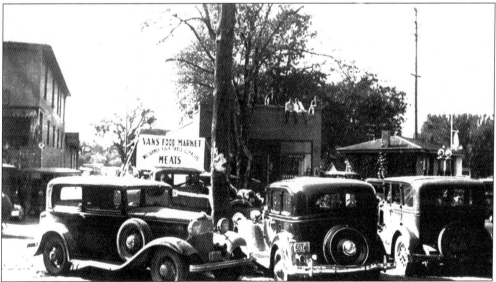

Hudsonville Fair parade watchers have prime viewing from the roof of the Nyhuis Grocery Store in 1934. The photograph was taken on the west side of Division Avenue, south of highway M-21. The Yonker and Boldt Store is on the left, along with Nyhuis Grocer and the Alward Gas Station. (Gary Byker Memorial Library.)

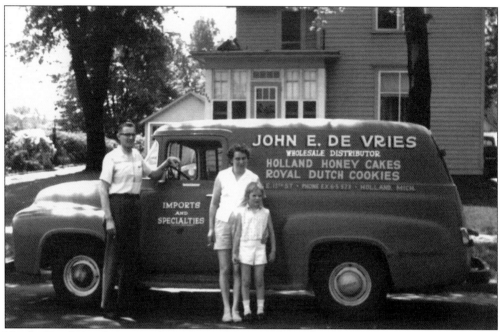

Vander Veen's Dutch Store and companion business, the Holland American Food Company, help keep the Michigan Dutch in touch with their roots by offering treats including windmill cookies, Droste chocolate, licorice, rusk, soups, and cheeses, along with wooden shoes, fine lace, and the blue and white delft porcelain that is a Netherlands trademark. Above, John De Vries, founder of the import and cookie business, stands with his wife, Helen, in front of their company vehicle. John's son Rick took over the business and in 1996 and bought the Vander Veen Company. The store interior shows examples of the delft. (Holland American Food Company, Inc.)

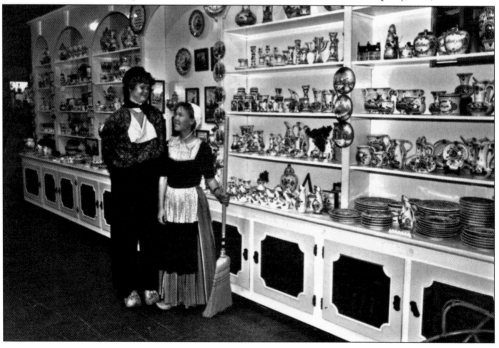

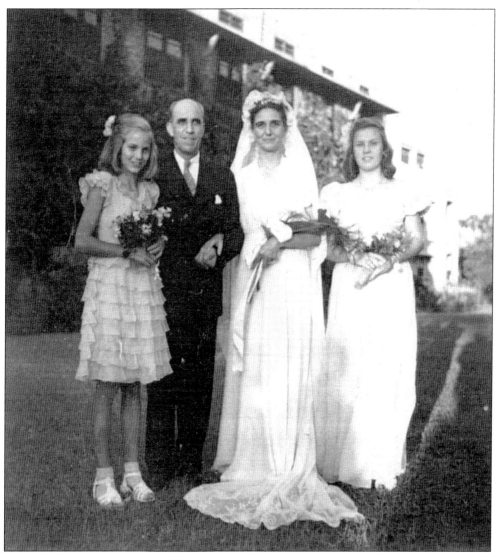

Dr. Bernadine Siebers De Valois achieved what few women ever dreamed of in the early 1900s. She became an ear, nose, and throat surgeon. Wanting to do more, she went to India as a Reformed Church of America missionary and served 25 years. There she became head of a hospital and met her husband, fellow missionary Dr. "Jack" De Valois. Seen here is her wedding photograph with her stepdaughters Francine and Margaret. She died in 2001 at the age of 92. (Ron Strauss.)

Grand Rapids' own "Dutch Master," Reynold Weidenaar was a master of intaglio techniques in printmaking and excelled in watercolors and oils as well. The son of a Christian Reformed minister, he eschewed abstract art, saying that not only did the art offend him but also the lifestyles of some of the abstractionists. He taught at the Kendall School of Art and Design, and his work is displayed in major museums. (Grand Rapids Public Library.)

Authors Meindert (left) and David DeJong pose at their parents' home in Grand Rapids. David moved to Rhode Island. Meindert remained in Grand Rapids and received a Newbery Medal for his children's classic *The Wheel on the School*. Among his other titles are *Shadrach*, *The House of Sixty Fathers*, and Newbery Honor–winning *Along Came a Dog*. Chris Van Allsburg also hails from Grand Rapids and is the two-time Caldecott Medal winner for *Jumanji* and *The Polar Express*. (Grand Rapids Public Library.)

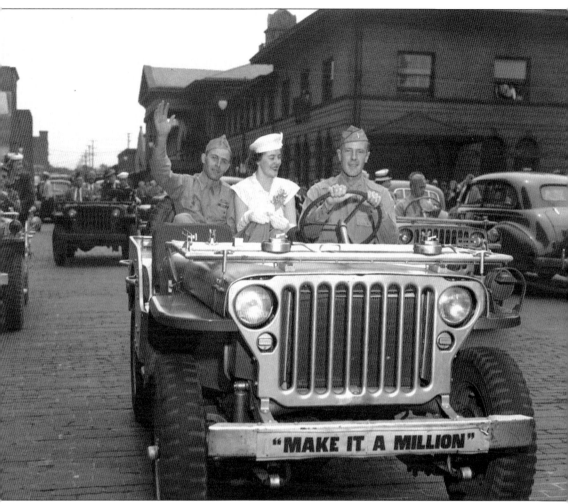

Dirk J. Vlug, a soldier from Grand Rapids, received a Medal of Honor for his actions in World War II. The citation ends, "Through his sustained heroism in the face of superior forces, Pfc Vlug alone destroyed five enemy tanks and greatly facilitated successful accomplishment of his battalion's mission." His hometown honored him on May 23, 1946, and the honorary name of the street around Grand Rapids' Veterans Park is Dirk Vlug Way. (Grand Rapids Public Library.)

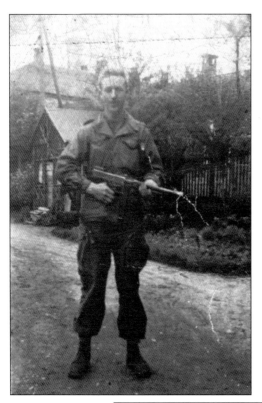

The Dutch were patriotic and proudly served in every war since the Civil War. Paratrooper Harvey De Vries left Grand Rapids in 1942 and served in the 506th Regiment, 101st Airborne Division, in World War II. He served in the Netherlands, where he helped liberate the village of Einhoven. He took a bullet through the chest and was left for dead. Medics rescued him behind enemy lines. Three months later he returned to active duty. On the 40th anniversary of that event, de Vries, with other members of his unit, visited the village, where they were welcomed royally. Today De Vries lives with his wife, Florence, in Byron Center. (De Vries family.)

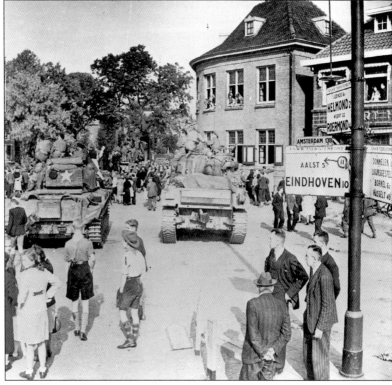

Eindhoven citizens welcomed the United States military in a show of gratitude for the their liberation. (Calvin College, Heritage Hall.)

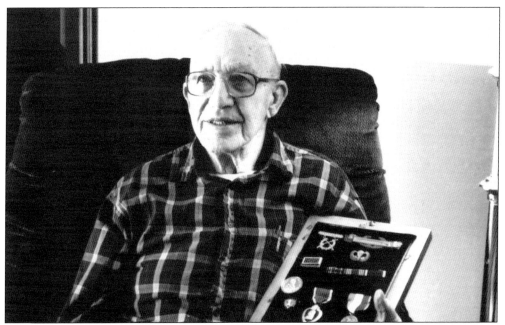

Harvey De Vries holds the medals, including a Purple Heart he received for his World War II heroism. (Norma Lewis.)

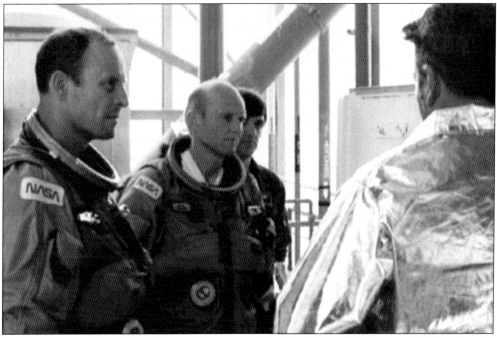

Jack Lousma was Grand Rapids' second astronaut. The first, Roger Chaffee, perished in a launch pad explosion that also killed Virgil "Gus" Grissom and Edward White. Lousma, a Marine Corps colonel, has been called the "Flying Dutchman," and was tapped for the space program in 1966. He spent 11 hours on two spacewalks outside the Skylab space station and also served as backup docking module pilot of the successfully completed Apollo-Soyuz Test Project in 1975. The Skylab 3 crew, from left to right, includes Owen Garriott, Lousma, and Alan Bean. (NASA.)

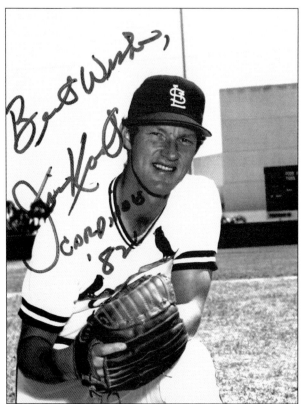

Zeeland-born left-handed pitcher James (Jim) Lee Kaat, nicknamed Kitty, joined the Washington Senators in 1957. When the Senators became the Minnesota Twins, he was starting pitcher in three World Series games in 1965, winning Game 2. The Twins took the American League pennant. After retiring from a 25-year career, he turned to baseball broadcasting with both CBS and ABC. (Zeeland Historical Society.)

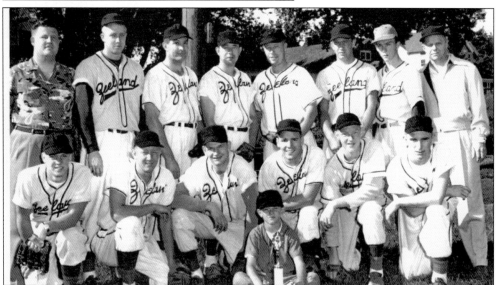

Before he was a major-leaguer, Jim Kaat played for the southwest Michigan semiprofessional baseball league where his pitching won the 1956 championship for the Zeeland Chix. Team members from left to right are (first row) Art Klamt, Gene Talsma, Ron Damstra, Ron Klamt, Kaat, and Tom Bos; (second row) Ned Bergsma, Dutch Mienema, Ted Boeve, Howard DeJonge, Don DeJonge, Ken Wiersma, Ron Beek, and manager Marinus Scheele. Bob Boerigter (Kaat's nephew and batboy) kneels in front of the team. (Zeeland Historical Society.)

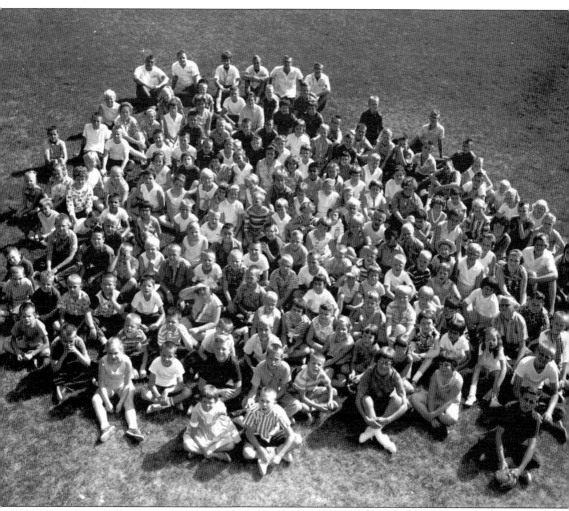

Still a close-knit Dutch community in 1963, the city offered wholesome summer recreational programs for kids bored with vacation and needing some structure to fill their days. Bill Robertson took his group photograph of participants. (Zeeland Historical Society.)

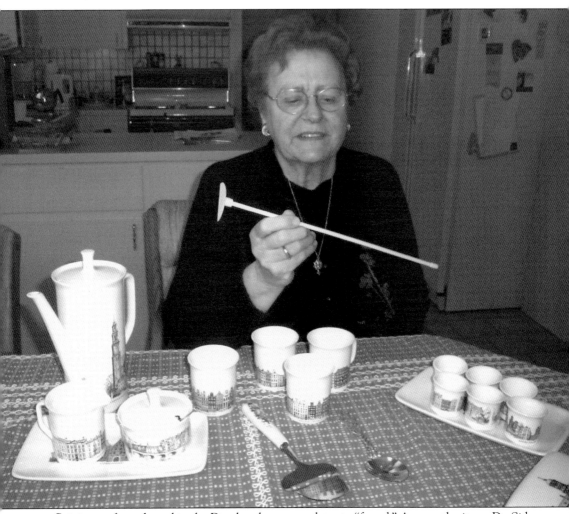

Zuinig, an oft-used word in the Dutch culture, translates to "frugal." Among the items Dr. Sidney and Marie Greidanus brought back from a visit to the Netherlands is the flessenkrabber held by Marie. The utensil is used to scrape the last bit of jam or applesauce from a jar. Also shown are two cheese cutters to make sure the Gouda is not sliced too thickly. But generosity coexisted with frugality. The sterling silver spoon was given to Sidney's father at birth, as was the custom in the old country. Note the Huegenot cross Marie is wearing. The cross was first designed and manufactured in 1688 and represents the beatitudes, the gospels, the apostles, and the Holy Ghost. (Norma Lewis.)

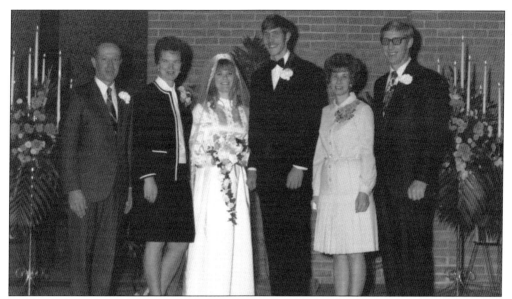

Rev. Jay de Vries officiated when his son David married Barbara Van Dam in the Calvin Seminary Chapel in 1971. On her mother's side, Barbara can trace her Dutch ancestry to her great-grandfather Hannes Zoet and her great-grandmother Albertje Ponstein, both of whom were born in the Netherlands in the 1860s and immigrated to Blendon Township. David was born in Kent County. His ancestors also came from the Netherlands, but to the Lucas-McBain area in northern Michigan. The couple met at Calvin College. From left to right are Elmer Van Dam, Nella Van Dam, Barbara, David, Marcia de Vries, and Jay de Vries. (David and Barbara De Vries.)

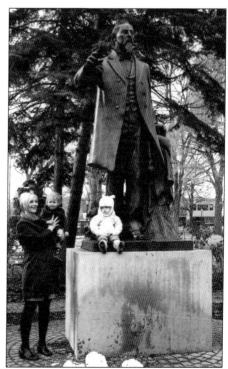

The line continues with two more generations. David and Barbara's daughter Jill Berry is holding her daughter Bella. Bella's dad is Thomas Berry. Laken De Vries, daughter of Schuyler and Julie De Vries, perches on the statue of Albertus Van Raalte at Holland's Centennial Park. (Norma Lewis.)

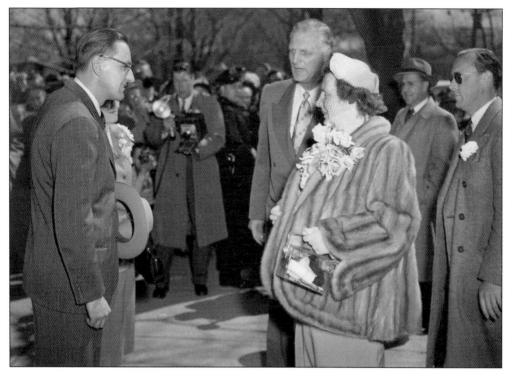

One way Dutch Americans honor their ancestors' homeland is through honoring the Netherlands royal family. During their American trip in 1952, Queen Juliana and Prince Bernhard visited Calvin College. College president William Spoelhof escorted the queen. Angeline Spoelhof is partially hidden at the prince's left. (Calvin College, Heritage Hall.)

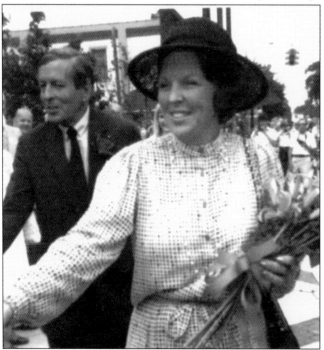

After a visit from Queen Beatrix and Prince Claus, the Zeeland Chamber of Commerce placed a marker at 149 East Main Street stating, "At this place on June 16, 1982, Queen Beatrix of the Netherlands was presented to the people of Zeeland." (Zeeland Historical Society.)

Six

THE LEGACY

The Dutch legacy in the two-county region is vast and ongoing. Their generosity to the community is legendary and covers philanthropy, entertainment, and a deep commitment to keeping their heritage alive. From the earliest days, whenever they perceived a need, they quickly acted to fill it. That legacy began with Albertus C. Van Raalte, who founded Hope College and Western Seminary in Holland.

In Grand Rapids, Calvin College and Calvin Theological Seminary opened their doors in 1876. Kuyper College, first called Reformed Bible Institute, was established in 1940. The immigrants' respect for education shows in other ways as well. The Calvin College library is named for Edsko and Claire Hekman, whose support helped make it a reality.

Contributions to the arts and entertainment include the works of Chris Van Allsburg, Meindert and David DeJong, Paul de Kruif, and Reynold Weidenaar. A statue of United States senator Arthur Vandenberg graces the downtown Grand Rapids corner of Monroe Avenue and Pearl Street. The Frederik Meijer Gardens and Sculpture Park features the Leonardo Da Vinci horse. Performing arts can be enjoyed at the De Vos Performance Hall, the Meijer Majestic Theatre, the Van Singel Fine Arts Center, and through endowments made to local colleges. The Van Andel Arena hosts professional hockey and basketball games, along with concerts and other events.

Visitors and residents can take a walk on the slightly wild side at the Frederik Meijer Nature Preserve in Kent County or at Holland's De Graaf Nature Center, which, in partnership with Van Raalte Farm, offers learning and recreational activities.

The Dutch contributed to the cutting-edge health care available in Grand Rapids via the Fred and Lena Meijer Heart Center, Helen De Vos Children's Hospital, the Holton and Lemmen Cancer Center, the Van Andel Institute, and Pine Rest Christian Mental Health Services.

Veldheer's Tulip Gardens, Windmill Island, and Nelis Dutch Village all celebrate the heritage and its ongoing legacy. For ethnic celebration, nothing tops the Tulip Time festival when, for one week, everyone in Holland is Dutch and proud of it. Asian, Hispanic, and African American students and adults don costumes to scrub streets and kick up their wooden heels in a Netherlands *klompen* dance.

Dutch names appear on the buildings at Calvin College and Hope College, and a drive through most neighborhoods shows streets named for the early pioneers. That alone speaks volumes about the impact those people had on their adopted home. But their most important legacy remains the strong values the early settlers passed on to their progeny that shaped the region into what it is today.

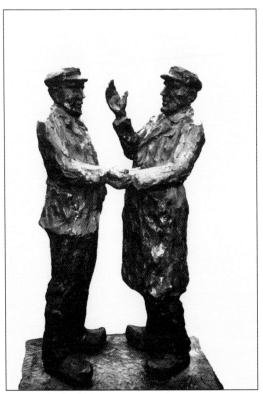

The Dutch were, and still are, known for personal integrity. This statue conveys the message that a Dutchman's handshake alone is enough to cement a deal. (Heritage Center, Graafscap Christian Reformed Church.)

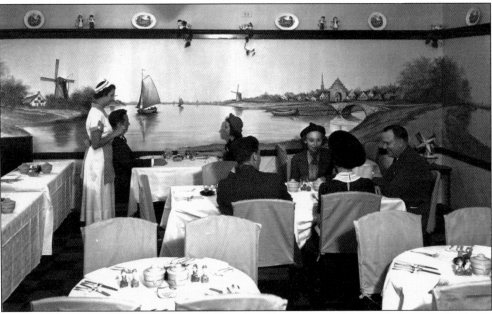

Guests dine in front of the detailed mural of the old country in the Dutch room at the Rowe Hotel in Grand Rapids in 1938. The ambience appealed both to the local Dutch and to the ever-increasing number of tourists finding their way to the city by the 1930s and 1940s. The shelf above the mural displays delft china plates and other Dutch knickknacks. (Grand Rapids Public Library.)

Holland remains proud of its Dutch roots. Here a museum guide shows part of the folklore exhibit at the Holland Museum. This piece was chosen to introduce the heritage section. Built in the Netherlands and shown at the 1939 New York World's Fair, it is a map of the country with lighted displays of traditional festivals. (Norma Lewis.)

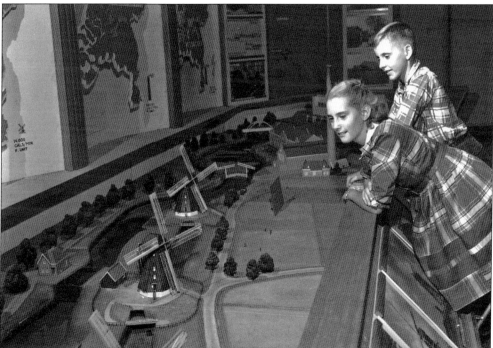

When the Grand Rapids Public Museum planned a Dutch heritage display in 1949, this boy and girl enjoyed a sneak preview of the miniature village. (Grand Rapids Public Library.)

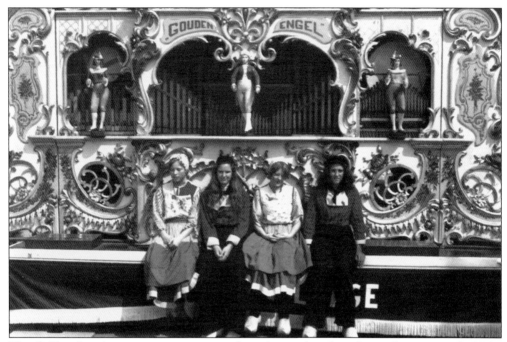

The Golden Angel, an antique street organ from Amsterdam, has charmed visitors to the Nelis Dutch Village theme park in Holland since its arrival in the 1930s. The figures depict Dutch dress while the ornate carving adds to the overall beauty. Such organs were a common sight in the Netherlands and provide a bit of nostalgia to locals while giving tourists a delightful peek into this area's roots. (Nelis Dutch Village.)

Sinterklaas arrives on horseback to begin the Christmas holiday season at the Dutch Village theme park. Two of Santa's reindeer also have roots in the Netherlands: In his original 1823 version of *The Night Before Christmas*, Clement Moore used Dunder and Blixem, the Dutch words for thunder and lightning. (Nelis Dutch Village.)

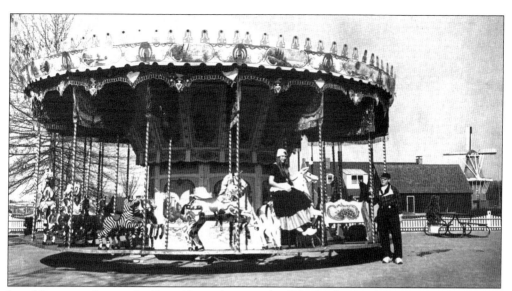

In addition to the windmill itself, another popular Windmill Island feature is this antique *draaimolen* (carousel) built in Alteveer, Groningen, Netherlands, in 1908 and relocated to Holland in 1971. It features 28 hand-carved and hand-painted horses and barrel organ music. While the park was closed for the season in the winter of 2002–2003, Michigan artist Lisa Freeman restored the painted murals depicting Dutch life. (Holland Museum.)

Nothing symbolizes the Dutch more than tulips. Vern Veldheer started a perennial garden in 1950 with 100 red tulips and 300 white. Now visitors enjoy more than five million tulip blooms, along with daffodils, hyacinths, and more. Veldheer's offers bulbs, wooden shoes, delft, and other specialty Dutch imports, not to mention a herd of buffalo. (Norma Lewis.)

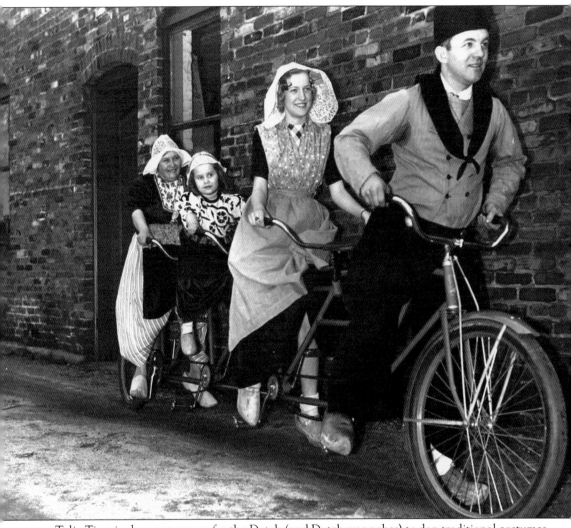

Tulip Time is always an excuse for the Dutch (and Dutch wannabes) to don traditional costumes and join the fun. This family looks sweet upon the seats of a bicycle built for four. (Joint Archives of Holland.)

Hollywood came to Holland's Tulip Time in 1939. Pictured from left to right are George Raft, Fay Wray, Holland mayor Henry Geerlings, Edmond Love, Mary Brian (about to tweak Lowe's nose), Ray Kronemeyer, and Connie Boersma. After being welcomed with wooden shoes and bouquets of tulips, the stars were taken to the Warm Friend for dinner. Over the years, other celebrity guests have included Netherlands queen Juliana, Pres. Gerald Ford, and Pres. Ronald Reagan. (Grand Rapids Public Library.)

When the folks in Holland catch Tulip Time fever, even their dogs are pressed into service. But it is done in the name of fun, and at least the pups are not required to klompen dance in wooden shoes. (Above, Grand Rapids Public Library; below, Joint Archives of Holland.)

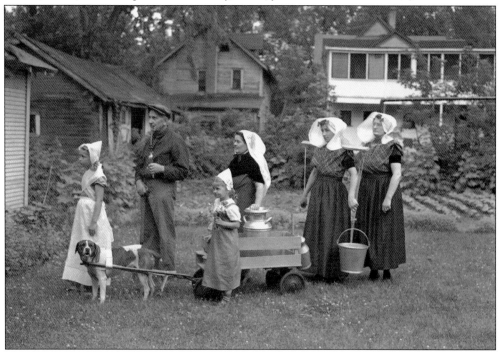

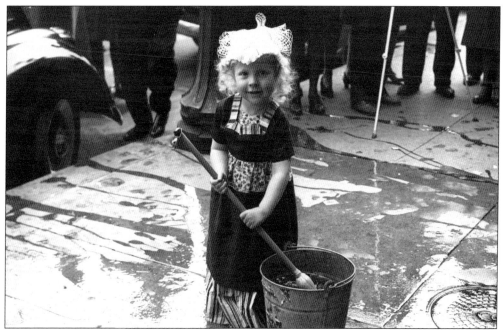

Nothing is more delightful than little girls in full Dutch regalia. This child (above) probably could not lift her bucket of water, but is nonetheless eager to scrub. Everyone gets in on the act. Not only do children dress in historically correct costumes, they even dress their dolls for the event. (Joint Archives of Holland.)

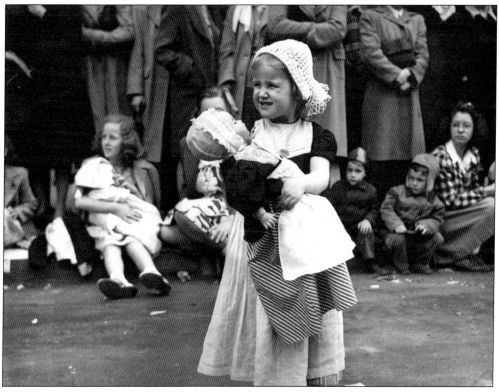

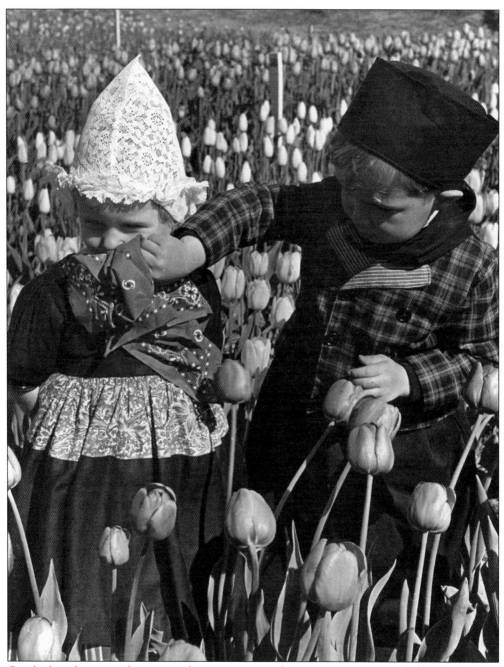

One look at these two charmers and it is easy to see why ever-increasing crowds from around the country tiptoe through Holland's tulips each year during the first week of May. (Joint Archives of Holland.)

Continuing the legacy of public service through politics started by Sen. Arthur Vandenberg and others are congressional representatives Vernon Ehlers (right) and Netherlands-born Peter Hoekstra (below), who replaced another Dutchman, Guy VanderJagt. Ehlers, of Grand Rapids, occupies the seat once held by the late former president Gerald R. Ford. (Right, Vernon Ehler's public relations department; below, Peter Hoekstra's public relations department.)

Terry Lynn Land was elected Michigan secretary of state in 2002 and reelected in 2006. (Terry Lynn Land's public relations department.)

The De Graaf Nature Center in Holland was named for Jacob De Graaf and contains 18 acres of trails, woodland, marshland, and ponds along with animals and more than 240 plant species. Some of their events start at the historic Van Raalte farmhouse. De Graaf worked for the city of Holland for 38 years, including 18 years as superintendent of parks and cemeteries. (De Graaf Nature Center.)

The Frederik Meijer Nature Preserve is one of many places bearing the name of the one-stop-shopping superstore family and also one of the least known—a prime spot to enjoy the abundant gifts of nature. (Kent County Park District.)

The Ada Covered Bridge, also known as the Bradfield Bridge, spans the Thornapple River and was first built in 1867. Farmers sometimes drove wagons filled with stones onto the bridge to hold it to its foundation during high water and threats of floods. When it was completely destroyed by fire in 1979, local citizens with funding from Amway Corporation and its founders, Rich De Vos and Jay Va Andel, erected an historically correct replica. (Norma Lewis.)

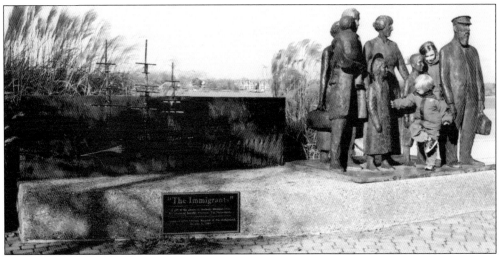

A statue honoring Holland's early settlers depicts an immigrant family and a replica of a ship similar to the *Southerner*. Children cannot resist this one at Kollen Park, named for settler G. J. Kollen, on Lake Macatawa. It was dedicated by Princess Margriet of the Netherlands on October 3, 1997, and commemorates the city's sesquicentennial. (Norma Lewis.)

Around the dawn of the 20th century, when mental health issues were swept under the carpet, Dutch physicians and clergy in Grand Rapids found a way to treat patients compassionately and ethically and to work with their spiritual as well as their medical and psychiatric needs. Christian Psychopathic Hospital admitted its first patients to this building in 1910. (Pine Rest Christian Mental Health Services.)

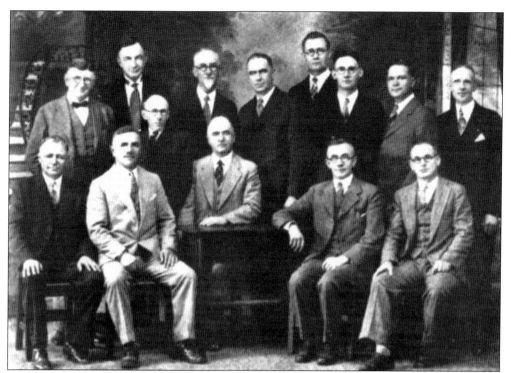

The Pine Rest Board of Directors is pictured in 1929. Now called Pine Rest Christian Mental Health Services, it remains a vital force in the southwest Michigan health care community. (Pine Rest Christian Mental Health Services.)

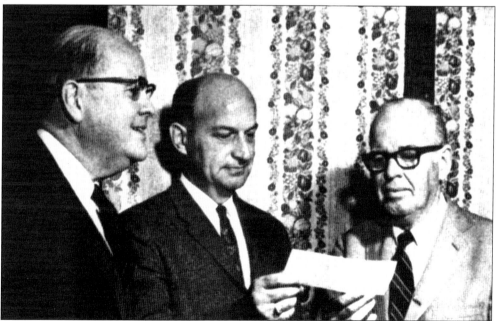

Pine Rest Foundation members Edsko Hekman (left) and Arthur Van Tuinen present a check to Herbert Daverman for the Christian Psychopathic Hospital. (Pine Rest Christian Mental Health Services.)

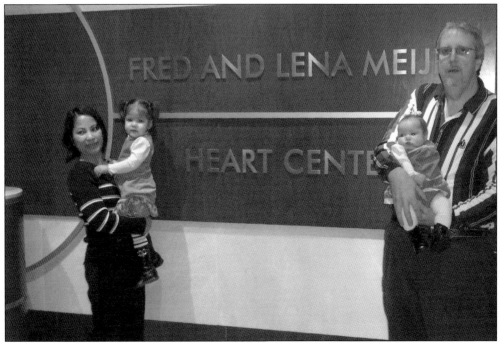

Daniel De Vries received a lifesaving heart valve transplant at Spectrum Hospital's Fred and Lena Meijer Heart Center. With him are his wife, Hazel, and daughters Iris (left) and Lily. (Norma Lewis.)

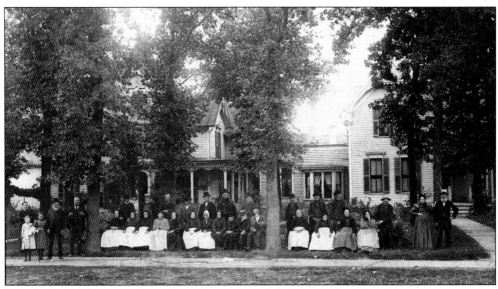

The Holland Home in Grand Rapids was established in 1892 when 26 men and women met to address their concern that the aged in their churches would be forced to enter state institutions. The facility they founded has grown to three campuses and the Faith Hospice and employs more than 1,100 people. Residents assembled in front of the first facility in the 1890s. (Holland Home.)

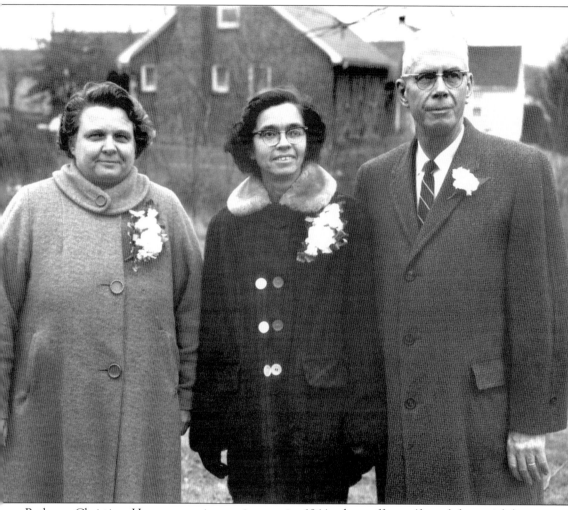

Bethany Christian Home came into existence in 1944 when officers (from left to right) Marguerite Bonnema, Mary DeBoer, and Andrew Vander Veer created a safe haven for homeless children. Services expanded to include pregnancy counseling, adoptions, and foster care. Now called Bethany Christian Services, 500 employees provide compassionate care to children on five continents, and by 2006 had placed 30,000 children with adoptive families. (Bethany Christian Services.)

Earl H. Beckering Sr. founded Pioneer Construction Company (first called Beckering Construction) in 1933 and almost lost it all in the 1950s when it became one of the first companies in Grand Rapids to go nonunion. The windows were shot out of his house, and arsonists torched his offices and warehouses. He made a comeback and the company is still thriving. The fourth-generation president, Tim Schowalter married Barbi Beckering, and the couple bought the company from her father, past president Tom Beckering, when he retired in 2005. (Pioneer Construction Company.)

Pioneer Construction built the Cook-De Vos Center for Grand Valley State College (seen here), the Gerald and Jane Ann Postma Center for Worship and Education at Pine Rest Christian Mental Health Services. Other construction projects with Dutch ties include Spectrum Hospital's Fred and Lena Meijer Heart Center and the Lemmon-Holton Cancer Pavilion. (Pioneer Construction Company.)

Discover Thousands of Local History Books
Featuring Millions of Vintage Images

Arcadia Publishing, the leading local history publisher in the United States, is committed to making history accessible and meaningful through publishing books that celebrate and preserve the heritage of America's people and places.

Find more books like this at
www.arcadiapublishing.com

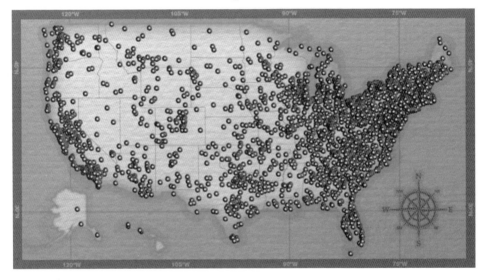

Search for your hometown history, your old stomping grounds, and even your favorite sports team.